BEAR PORTRAITS

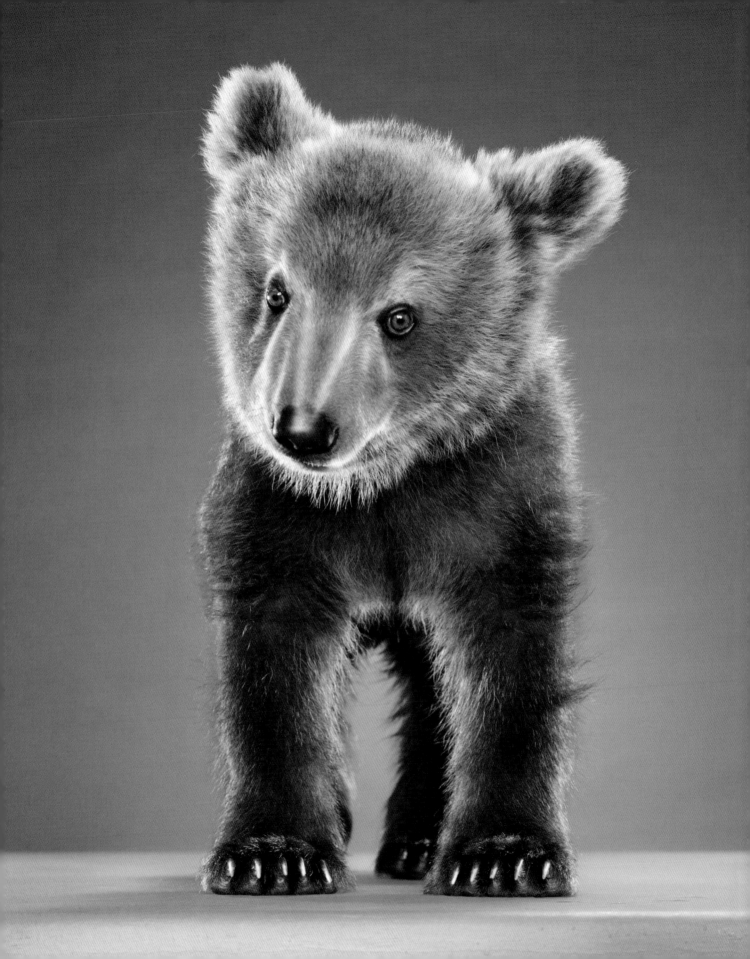

Photographs by

JILL **GREENBERG**

BEAR PORTRAITS

LITTLE, BROWN AND COMPANY

NEW YORK • BOSTON • LONDON

Best *bear* pictures ever;
although,
the lack of bearded gay men
is a little surprising.
TOM ARNOLD, ACTOR, COMEDIAN, TELEVISION HOST

These pictures are smarter than the

FYI: polar bears don't have white hair, it's actually transparent.
ED HELMS, ACTOR AND COMEDIAN

These pictures make a good case for the theory of evolution.
MATTHEW McCONAUGHEY, ACTOR

This is not
your father's book
of bear photos.
SETH MacFARLANE, ACTOR, COMEDIAN,
CREATOR OF *THE FAMILY GUY*

average bear.
ELVIS COSTELLO, MUSICIAN, SINGER, SONGWRITER

At a *bear* minimum, I would have
to say this book is genius.
ASHTON KUTCHER, ACTOR/PRODUCER

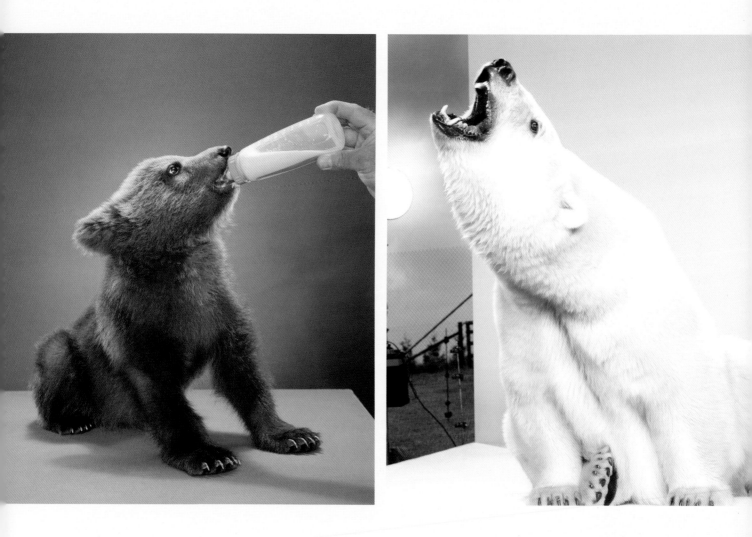

INTRODUCTION

I started planning this collection of bear photographs in the summer of 2006. It was just after exhibiting "End Times," a series of portraits depicting children crying. The return to animal portraiture was in reaction to the vitriol directed at me in response to "End Times." It felt "safer" to photograph these huge predatory beasts than the tiny but emotional toddlers who had the angry bloggers up in arms. As I embarked on the project, I intended to show epic bear power, their animalistic rage as an analogy to the human behavior I was experiencing.

I had discovered that Ruth La Barge in Alberta, Canada, had some of the best "close contact bears" in the world, and that I could shoot intimate portraits of them with my outdoor studio lighting setup. This setup requires an animal that can (a) stay on a mark for long periods of time while (b) not eating me or my crew. In August of 2006 I flew up to Calgary for my first shoot with six different bears: five Kodiaks and one black bear.

I went for a brief tour of the compound just after arriving, and Ruth introduced me to the various bears. When she asked the twenty-five-year-old, eight-foot-tall Kodiak Ali Oop to give me a kiss on the cheek, I realized I would survive the project. The next morning, as we began to shoot, I was examining my Polaroids; I was surprised to discover that the bears didn't look alive or real in the pictures. I don't think I had ever seen such a close-up, artificially lit bear picture; it was amazing to be able to examine the details of each bear's face and even the teeth inside their mouths. Usually when you are that close to a bear's mouth it's the last thing you see.

As the project continued and I photographed other bears, I realized I had to include a polar bear for reasons beyond their inherent beauty. Polar bears are short-timers on this planet, with probably twenty-five more years before they exist only in zoos. They are the canaries in the coal mine of global warming, and their world is being devastated. I believe that the consequences of their loss of habitat will soon become all too apparent to us as well.

I found a working polar bear named Agee outside Vancouver with her own private pool and personal compound. Mark Dumas, her owner, splits his time between there and California, where he also owns Koda, a massive 1,600-pound grizzly bear. The reason for the two homes is that U.S. authorities won't let Mark bring Agee into the country, so she is resentful of Mark every time he has to leave and for a while after he returns. Agee gets so possessive of Mark that she won't work directly with other women. Thus, while on the set with Agee, I was forced to communicate with Mark's wife, who would in turn talk to Mark, who would in turn tell Agee what to do. She was definitely the scariest bear I photographed. Polar bears are the most vicious predators on the planet.

Luckily for me, all of these animals are raised from birth to think that their trainers are their parents or, in some cases, their girlfriends. That the bears would sit like adorable Teddy bears—albeit Teddy bears with huge claws that could tear your flesh in an instant—and also stand on their hind legs and growl *silently* on cue, was surreal and amazing to me.

One of my favorite shoots was with Amos, the baby bear cub. I actually photographed him in the living room of our house just after I shot the young actress Abigail Breslin for *New York* magazine. Needless to say, she stayed on to see the adorable cub—as well as the chimp the trainer had brought along. During the shoot, the chimp played in my children's play structure in the backyard. Amos was solid and his hair coarse, not soft as I had imagined, and although he was just a four-month-old he was quite dangerous, too. To this day my son, who is three, asks if there is a baby bear coming to the house when I do a portrait shoot at home.

For the most part I make my living photographing well-known people. However, I have done animal portraits since I was very young. In fifth grade I was shooting pictures of my West Highland white terrier, Plato, with Vaseline on the lens, among other techniques. Now, for my creative work, I photograph trained animals with studio lighting in traditional portrait setups to explore and draw parallels with human qualities and behaviors. The veneer of socialization and intelligence that sets us apart from many other animals is just that—a veneer. In 2001, when I began the series of photographs that became *Monkey Portraits*, it was to show the striking similarities of character and "personality" between us and other simians. In photographing bears, I was looking to reflect the angry criticism that had been anonymously pointed my way. But that intent changed as the project grew. I learned to see the duality of the bears' nature, the irony in the misleadingly innocent outward appearance they often exhibit. This in turn brought to mind society's misguided anthropomorphization of all animals, and our denial of their true nature. Bears can be simple, sometimes savage animals, but they have as much right to survival on this planet as we do. They are magnificent creatures of immense power, emotion, and beauty. My images seek to capture the awe that they inspire.

—**Jill Greenberg, Los Angeles, California**

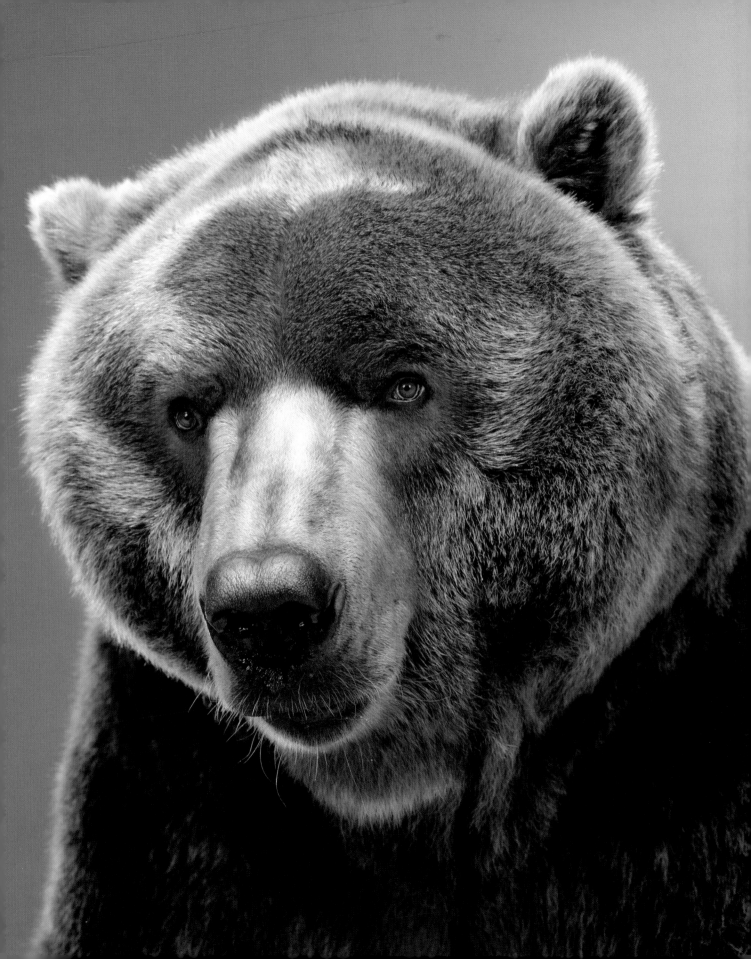

THE **PORTRAITS**

I don't think my parents liked me.
They put a live teddy bear in my crib.
WOODY ALLEN

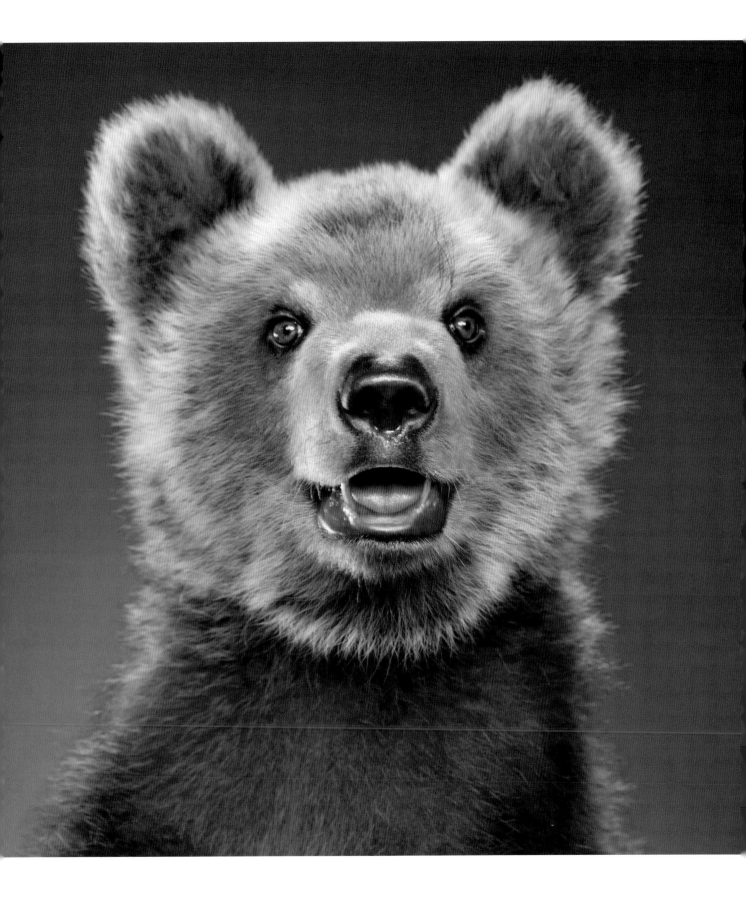

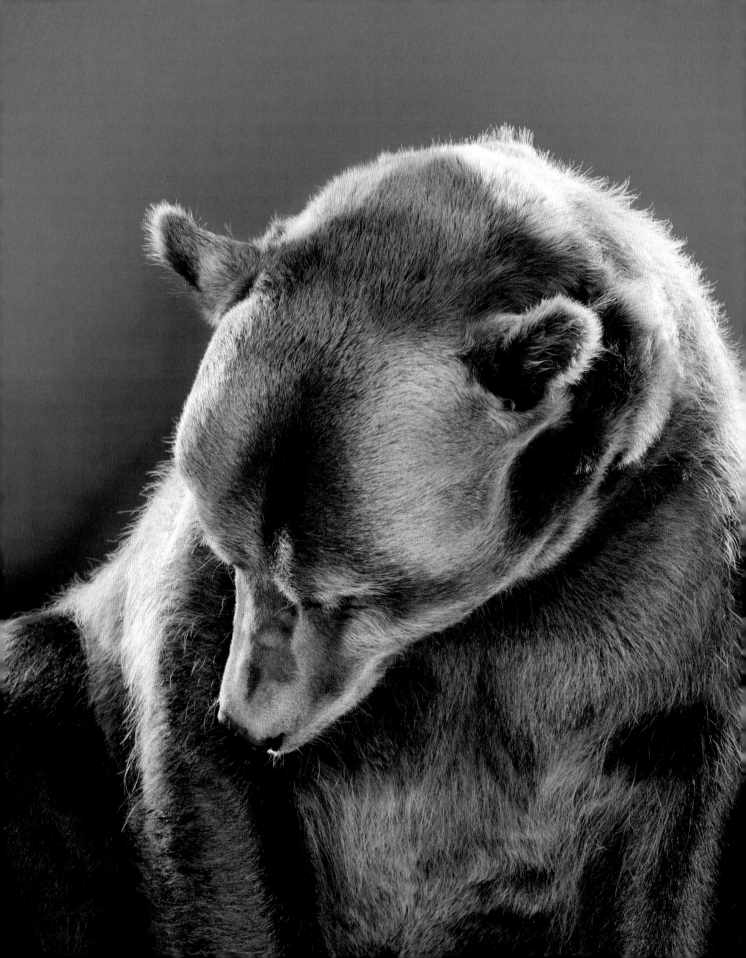

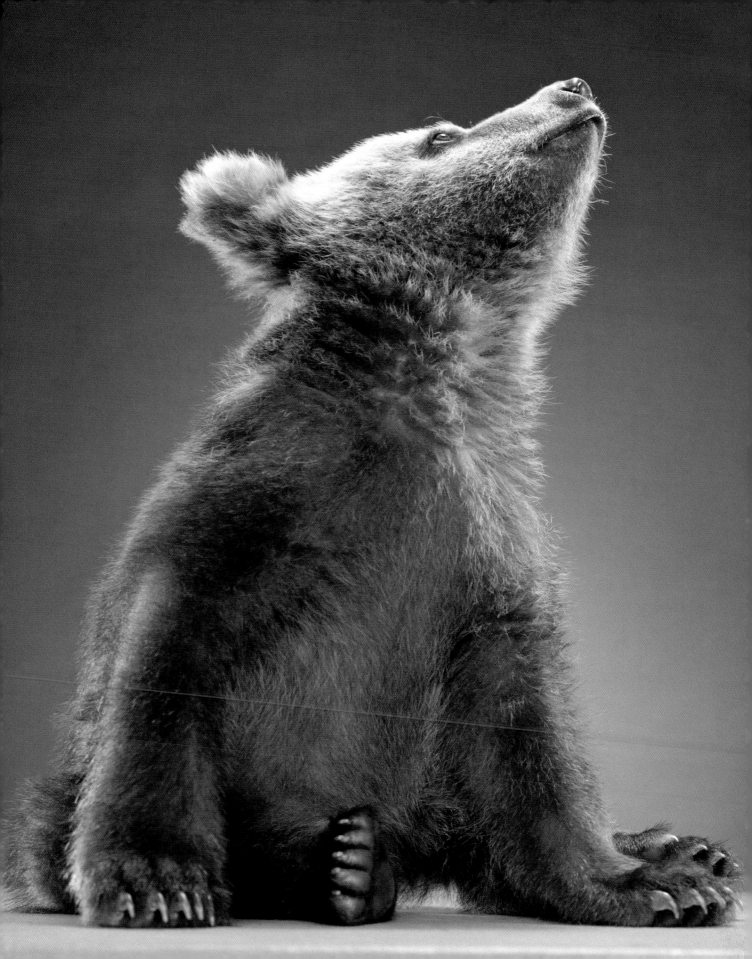

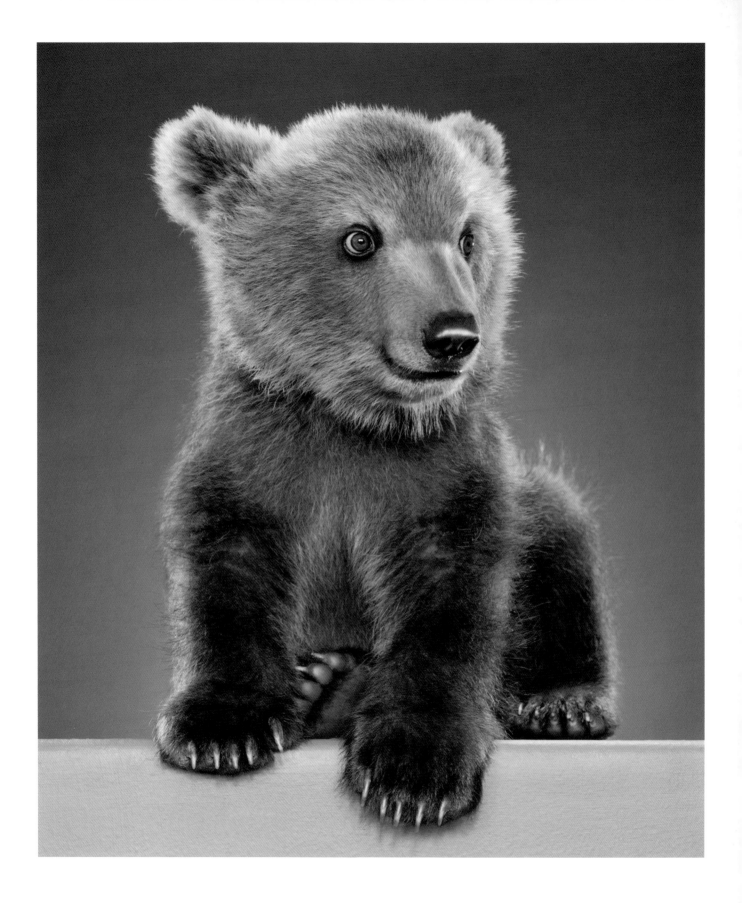

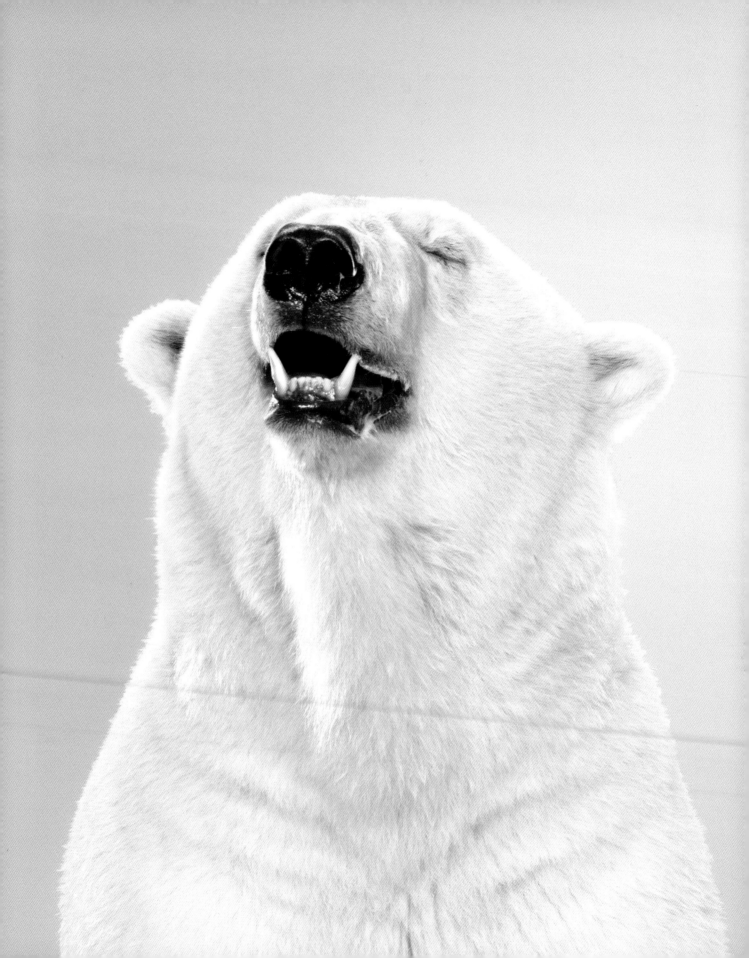

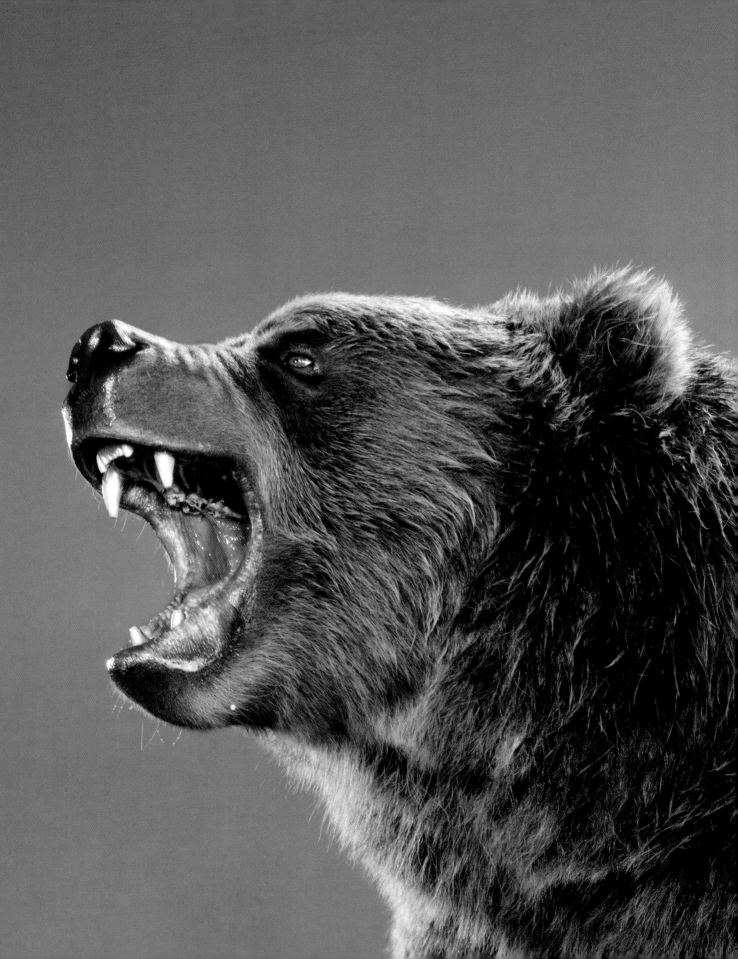

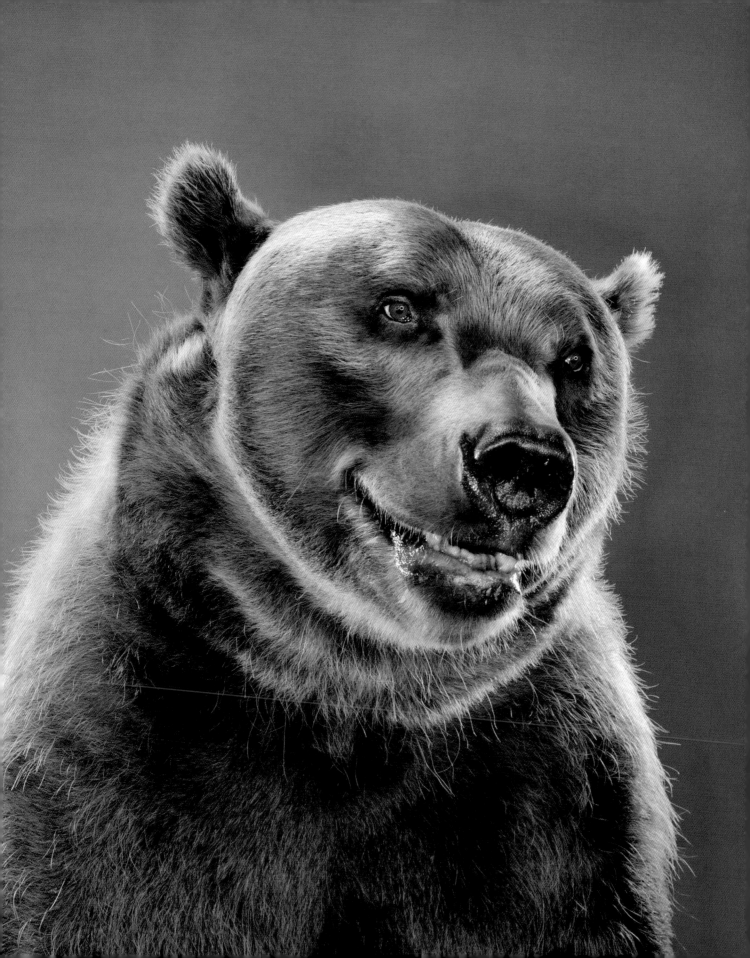

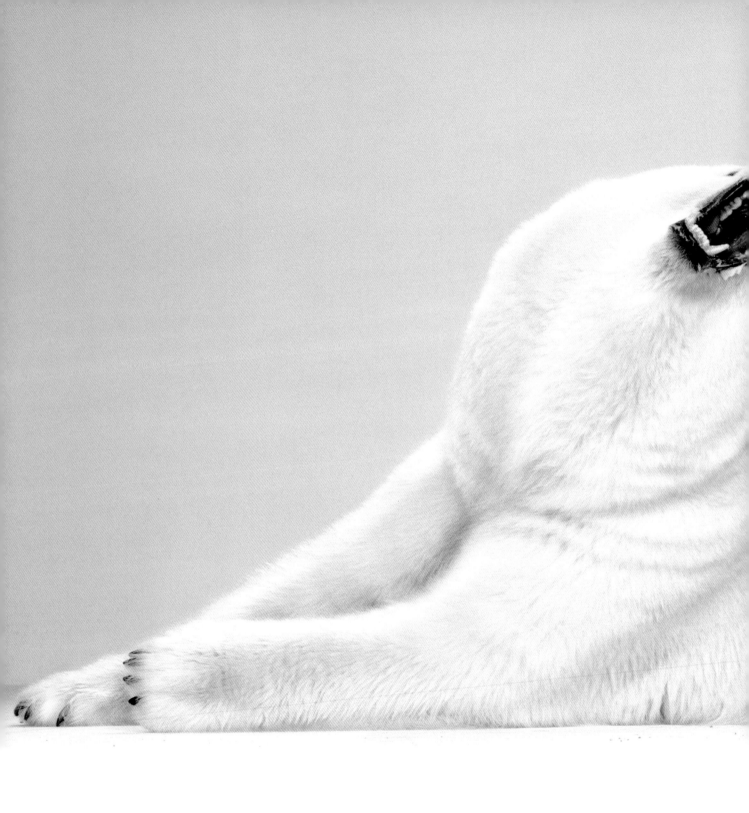

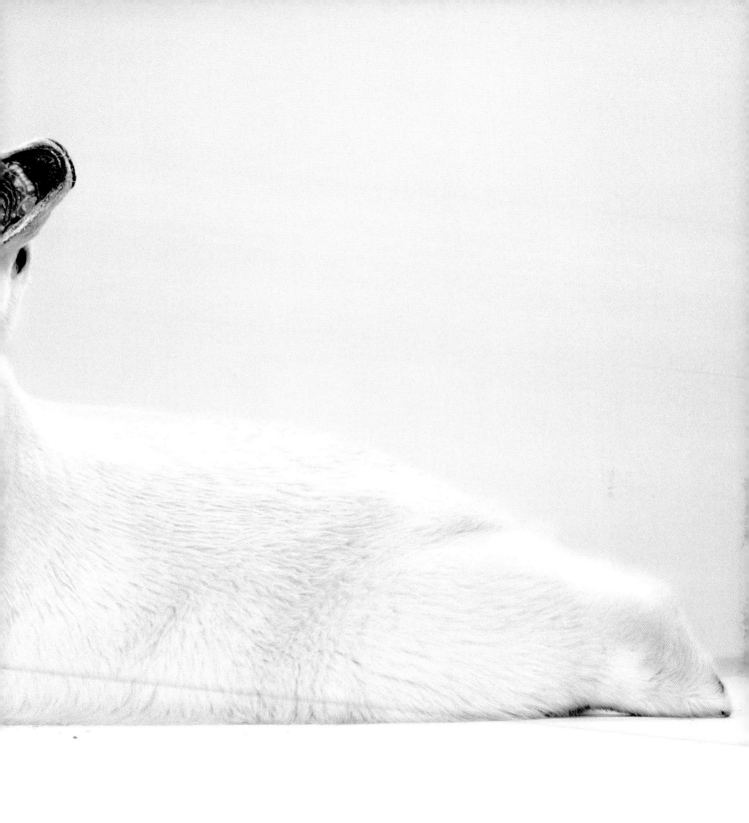

Be a good animal, true to your animal instincts.

D. H. LAWRENCE

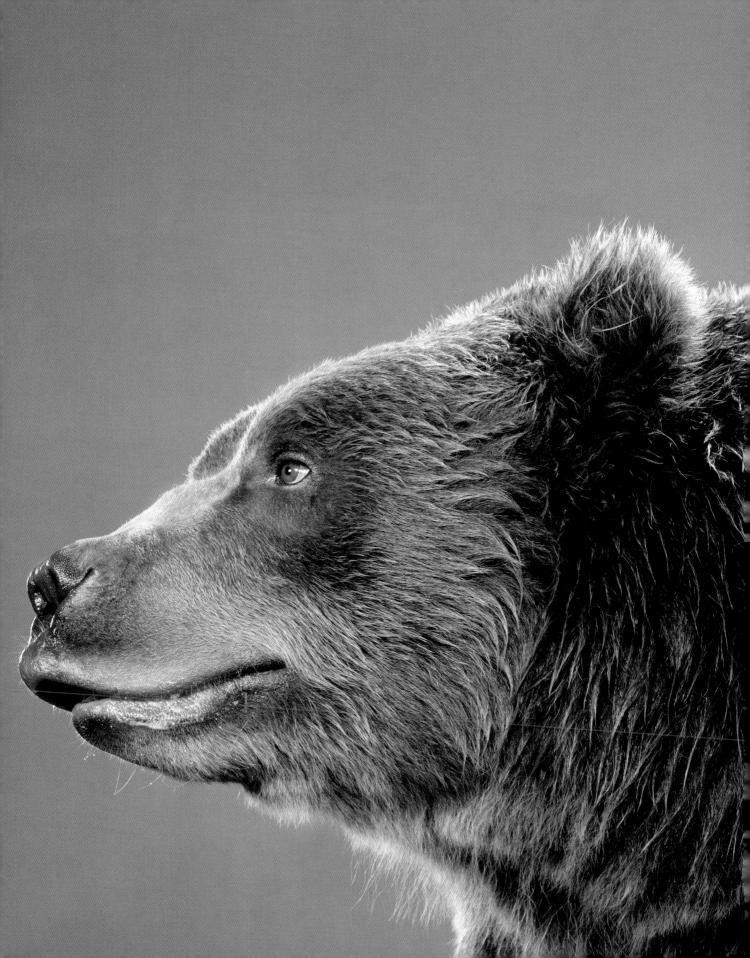

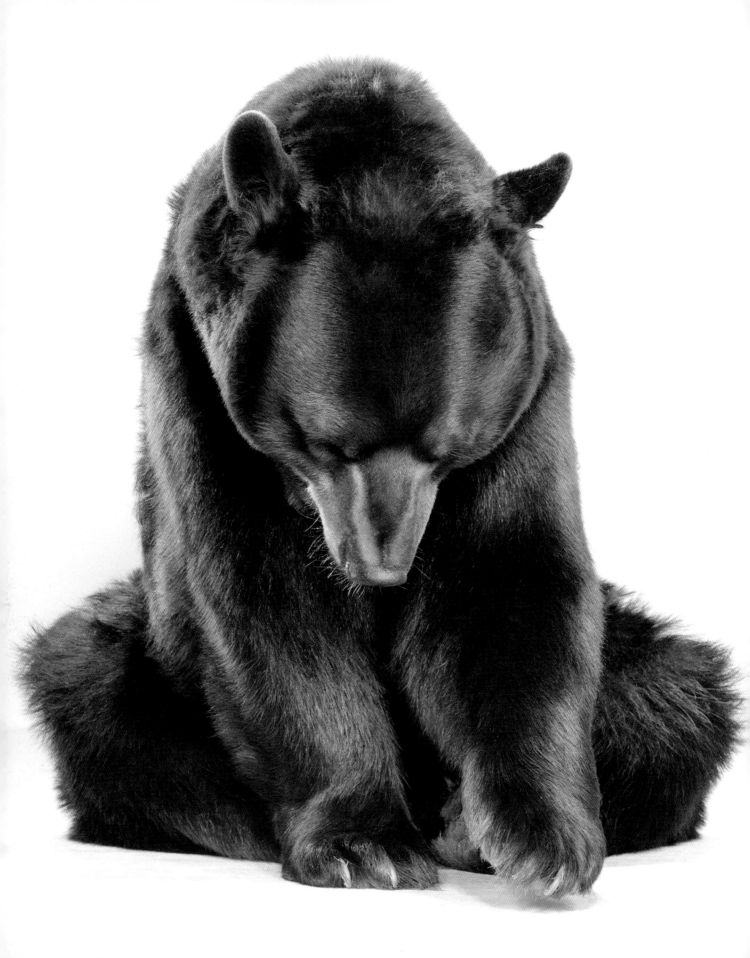

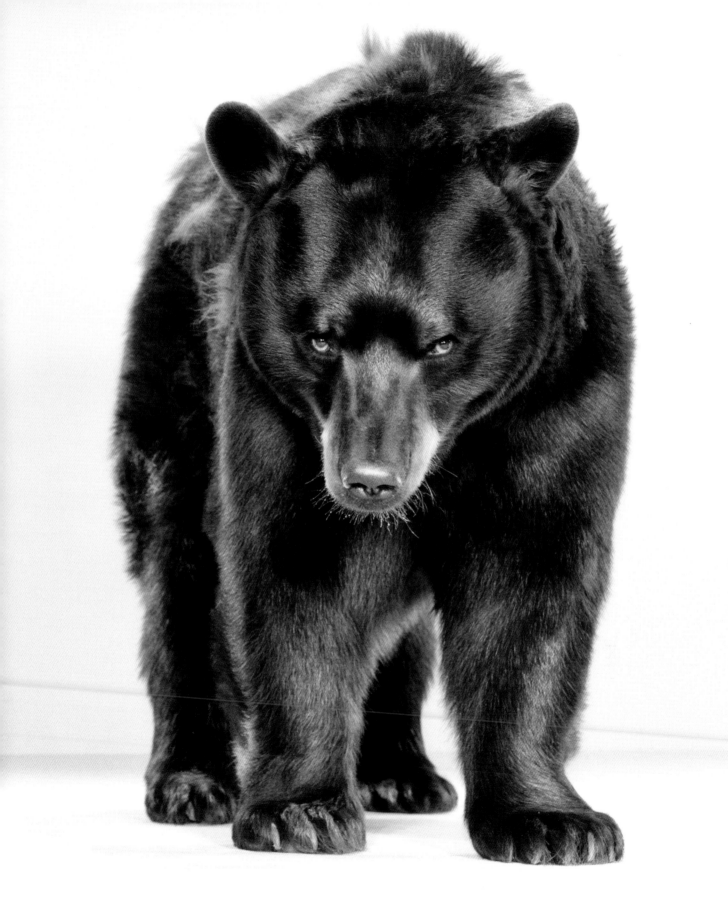

When among wild beasts, if they menace you, be a wild beast.
HERMAN MELVILLE

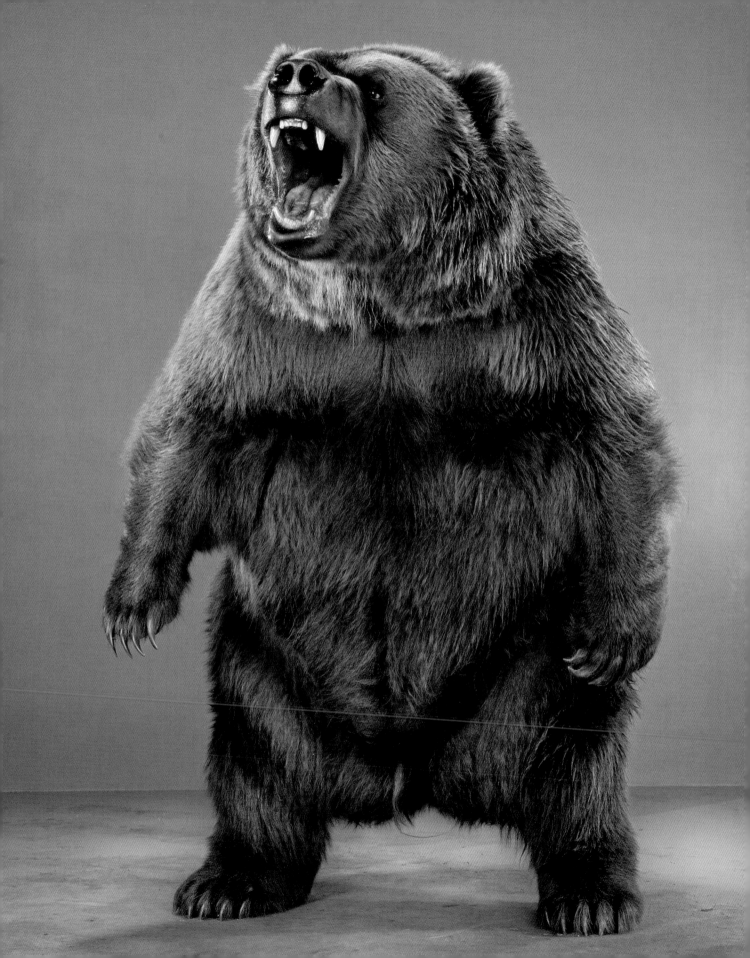

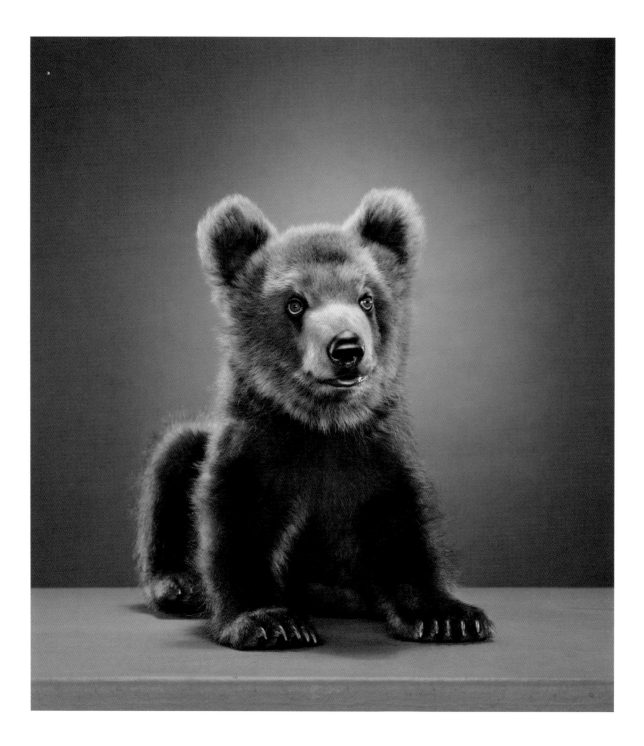

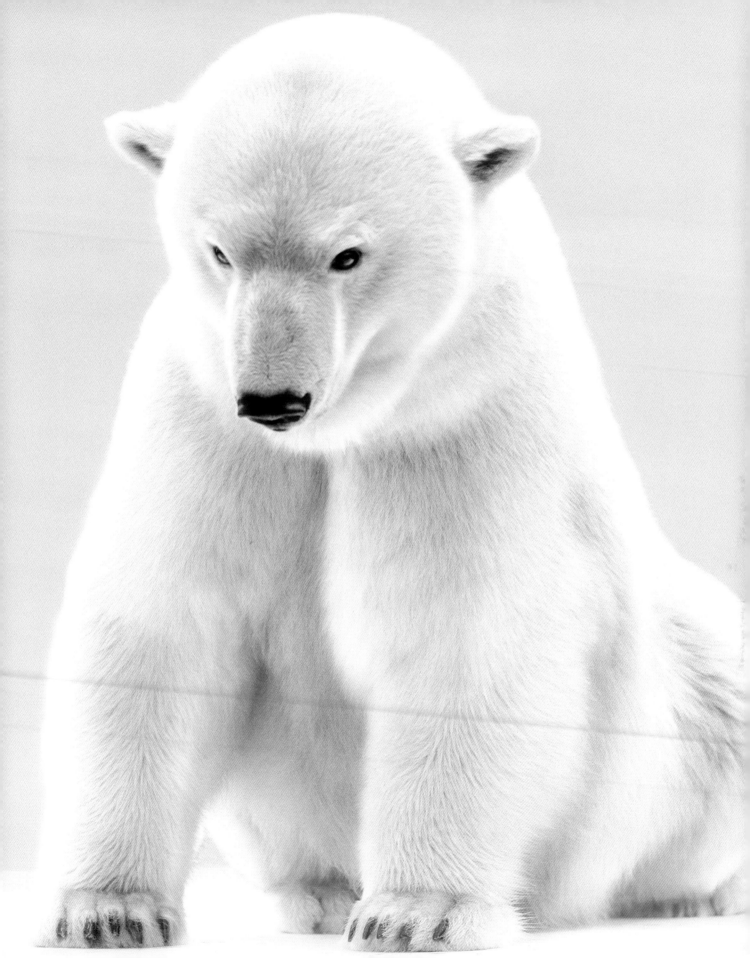

How does one kill fear, I wonder?
JOSEPH CONRAD

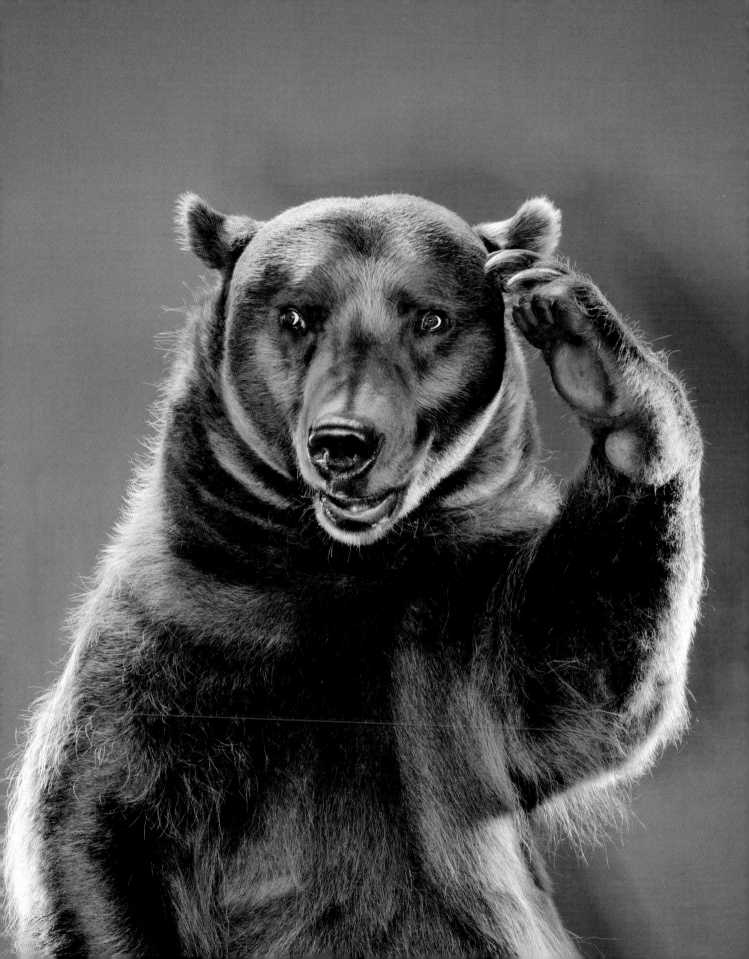

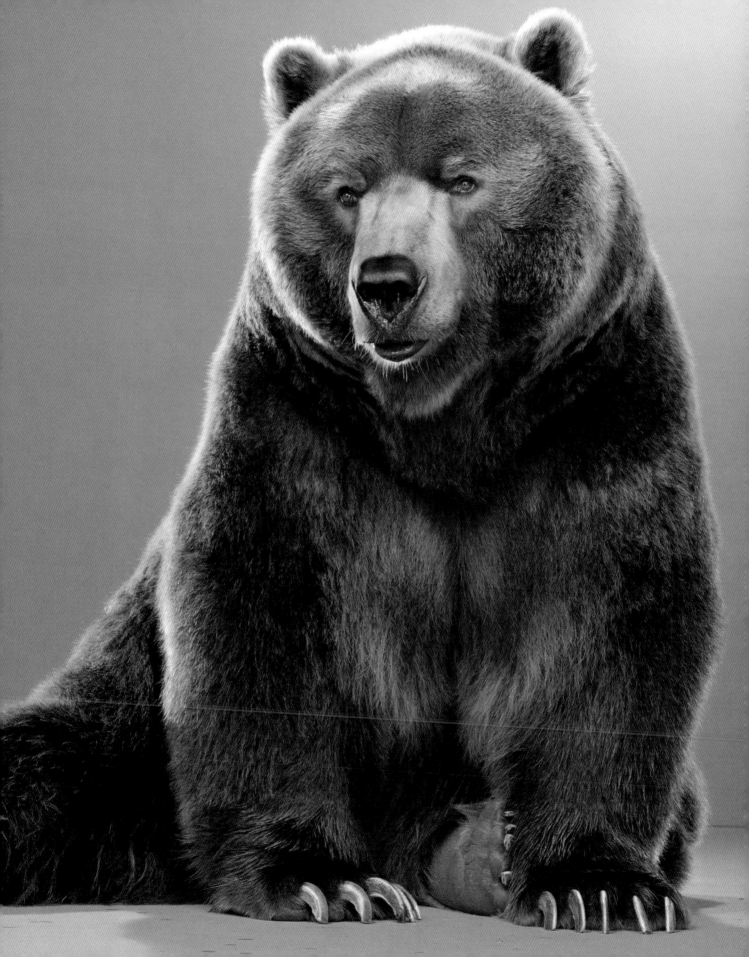

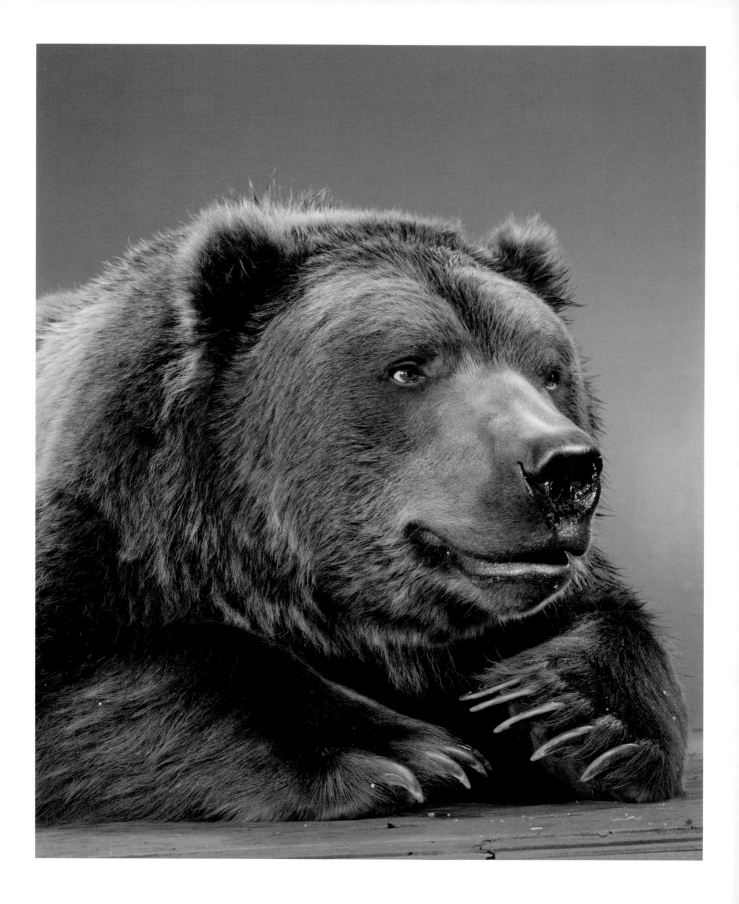

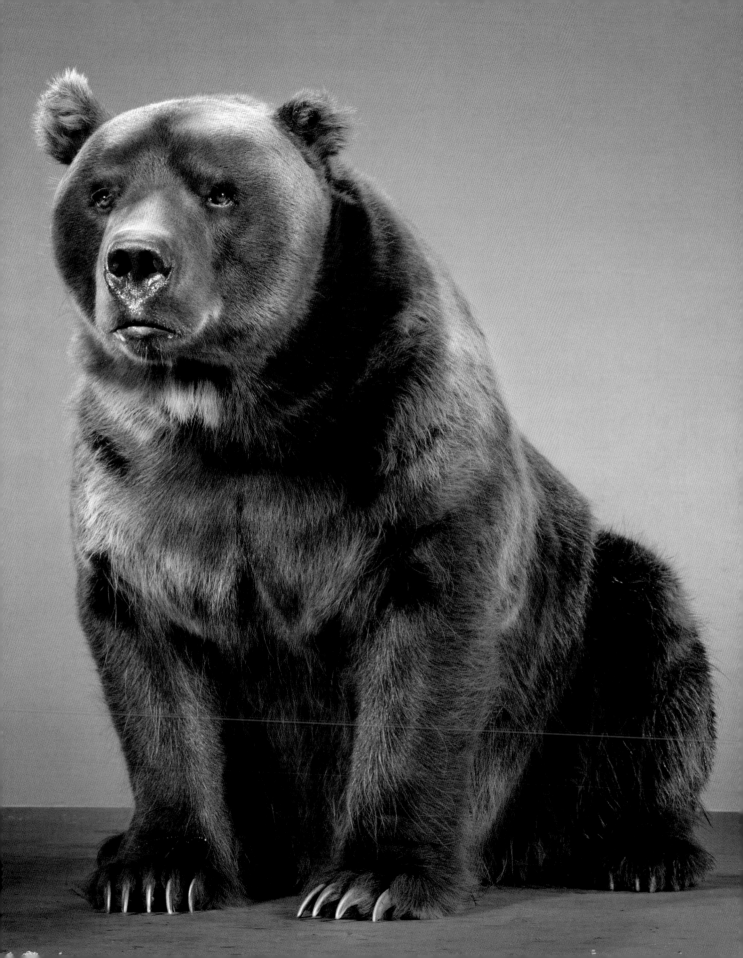

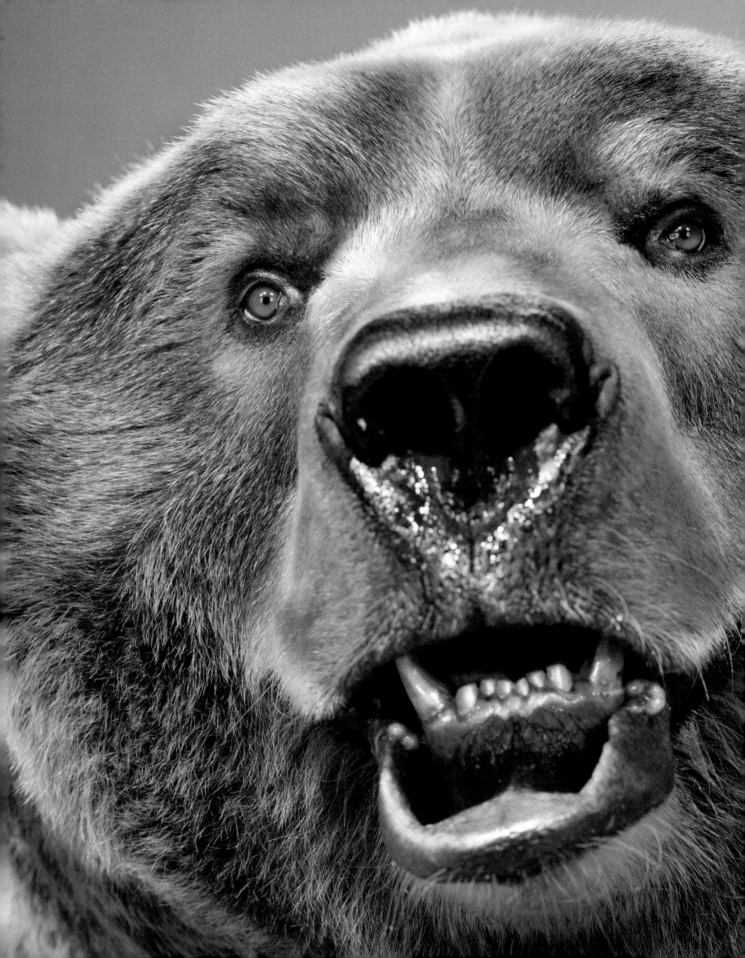

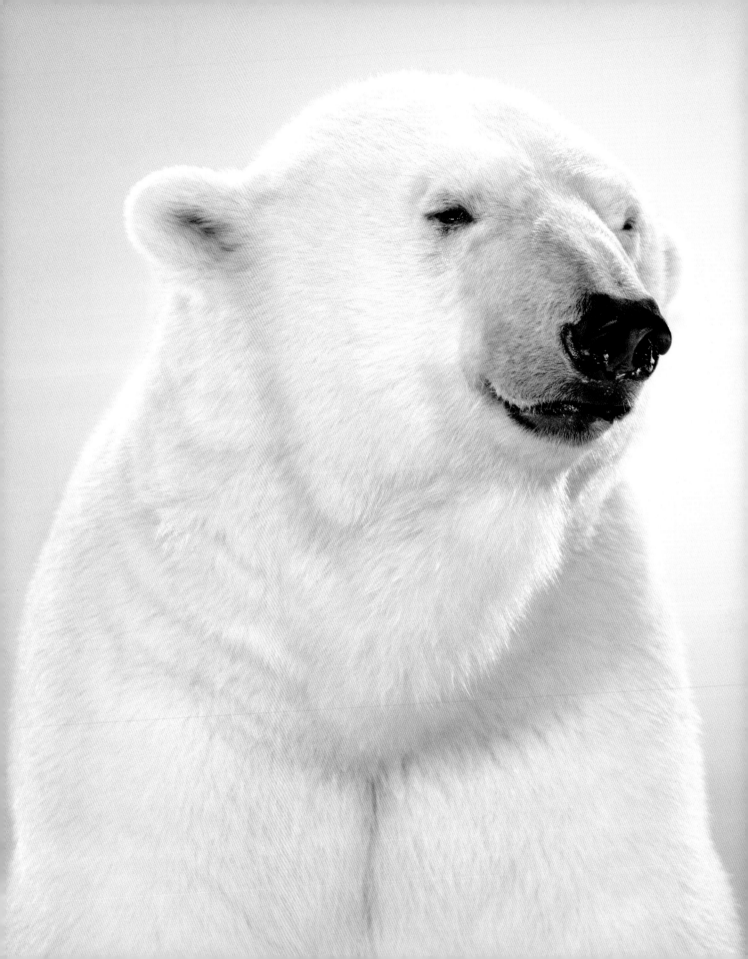

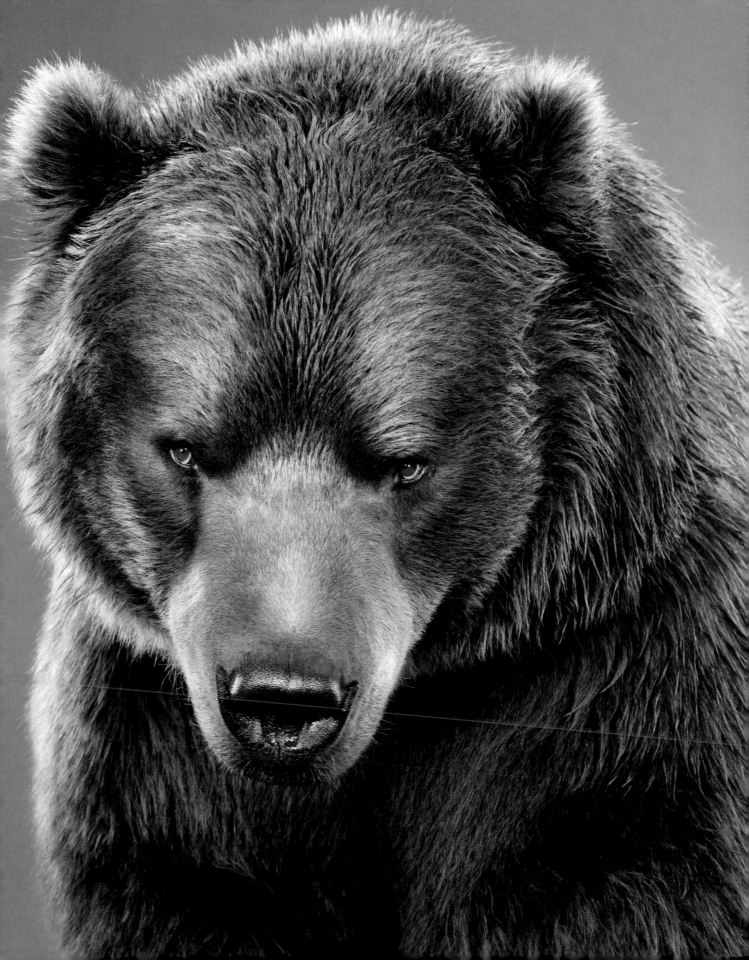

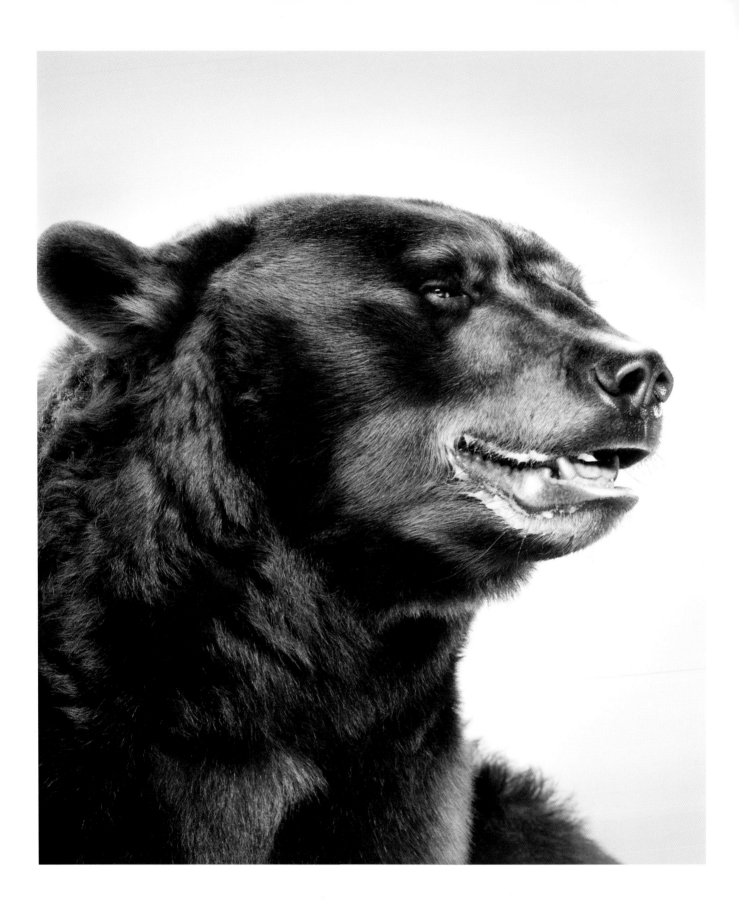

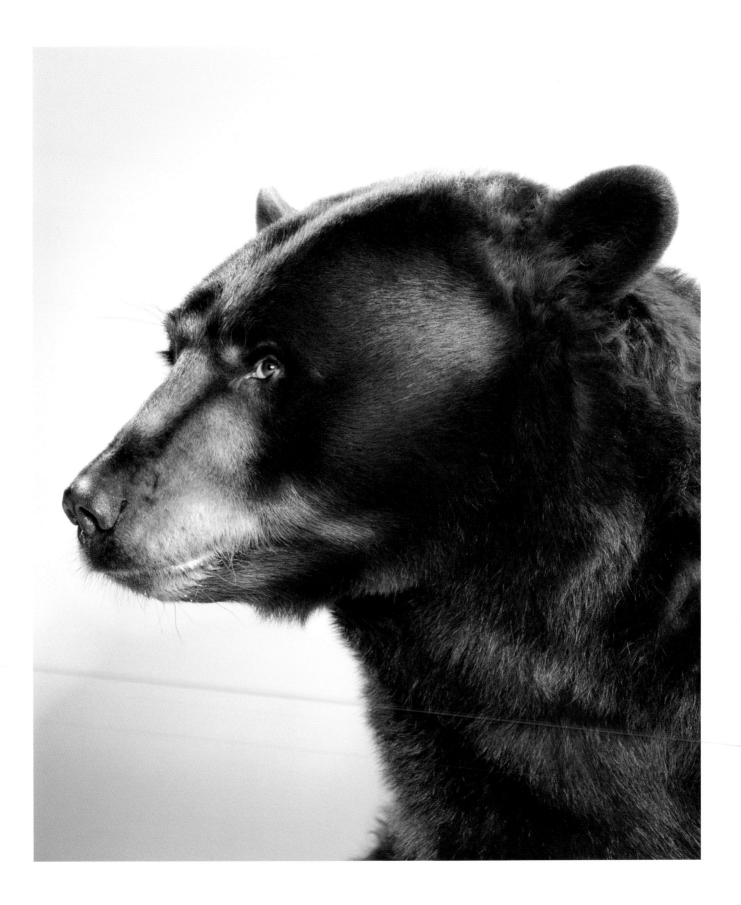

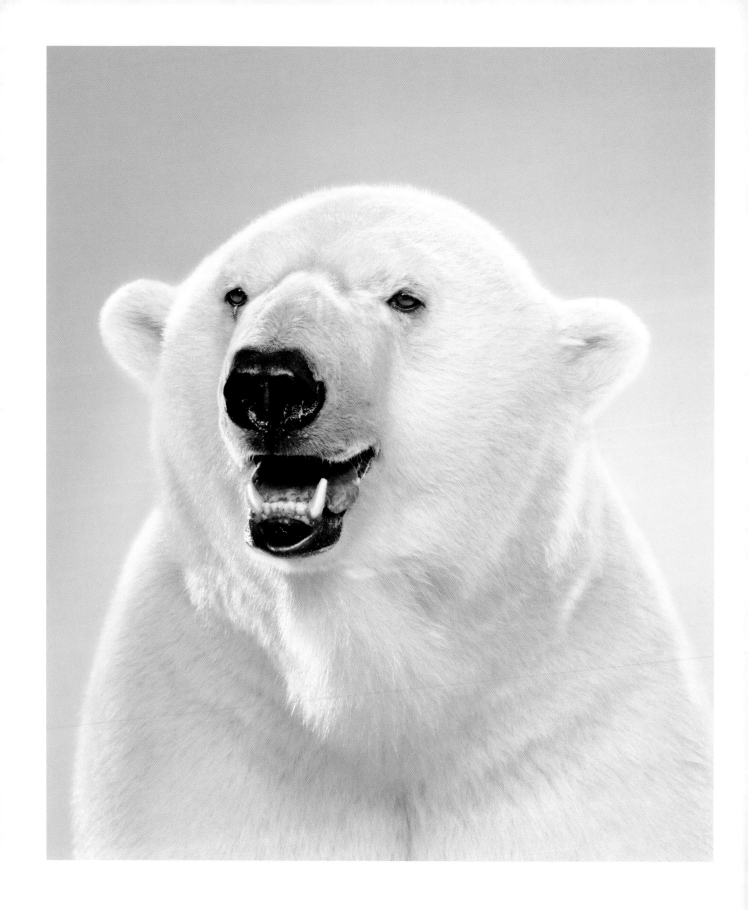

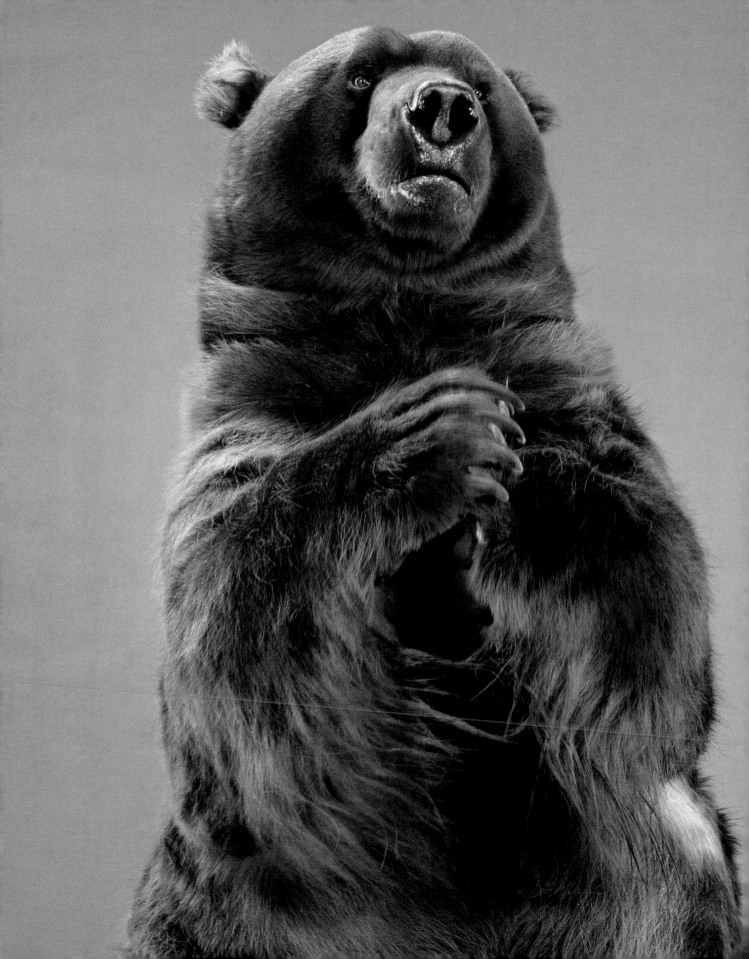

Only the gentle are ever really strong.
JAMES DEAN

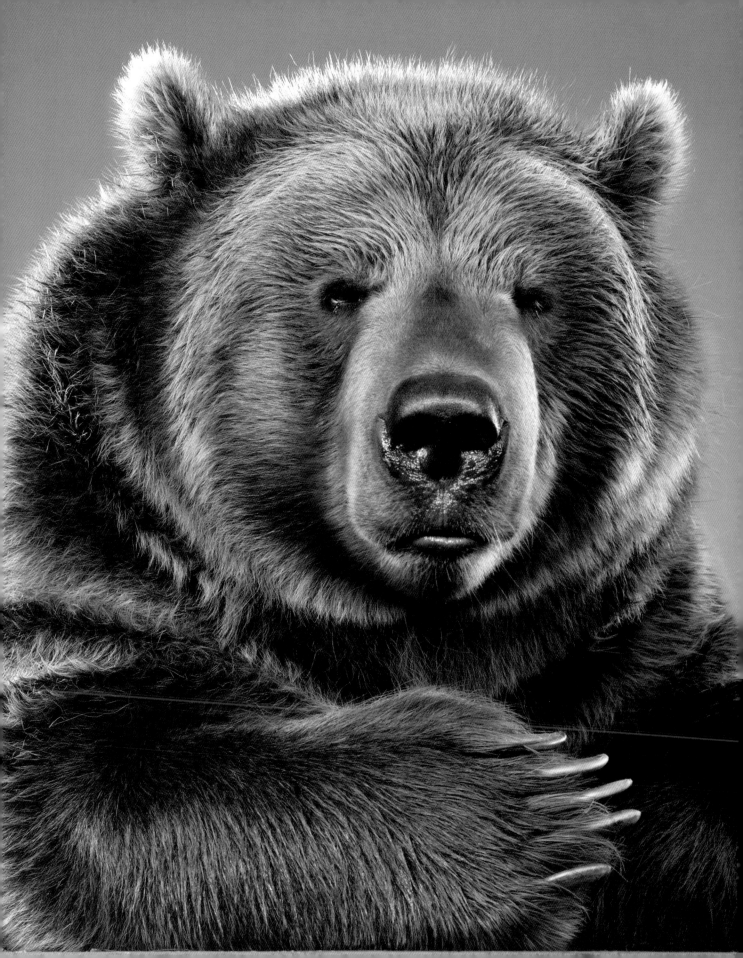

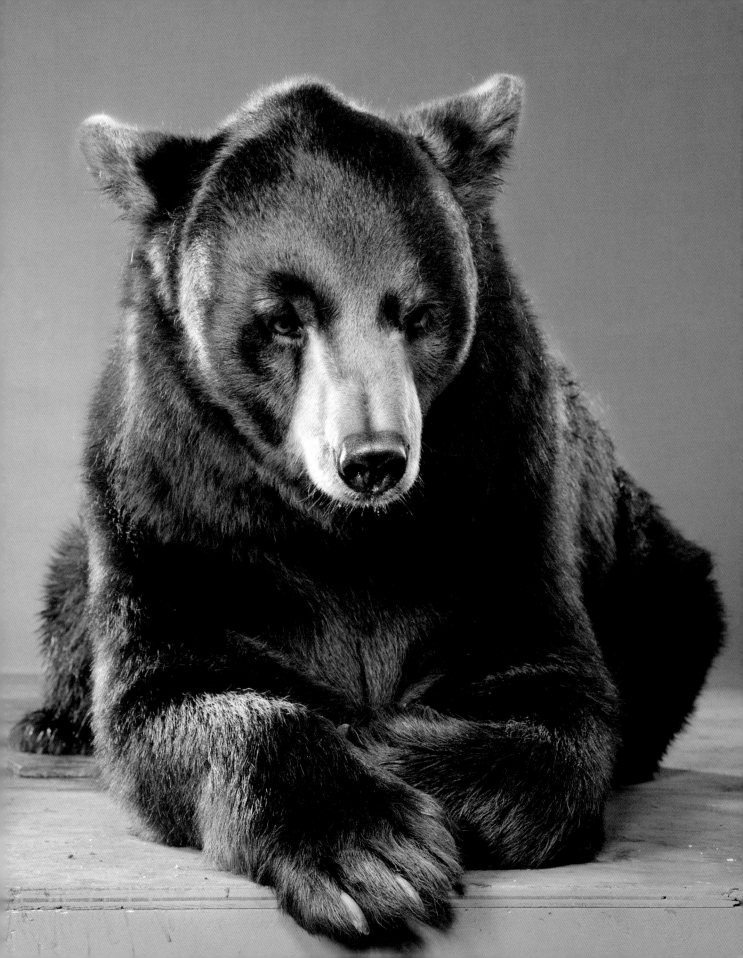

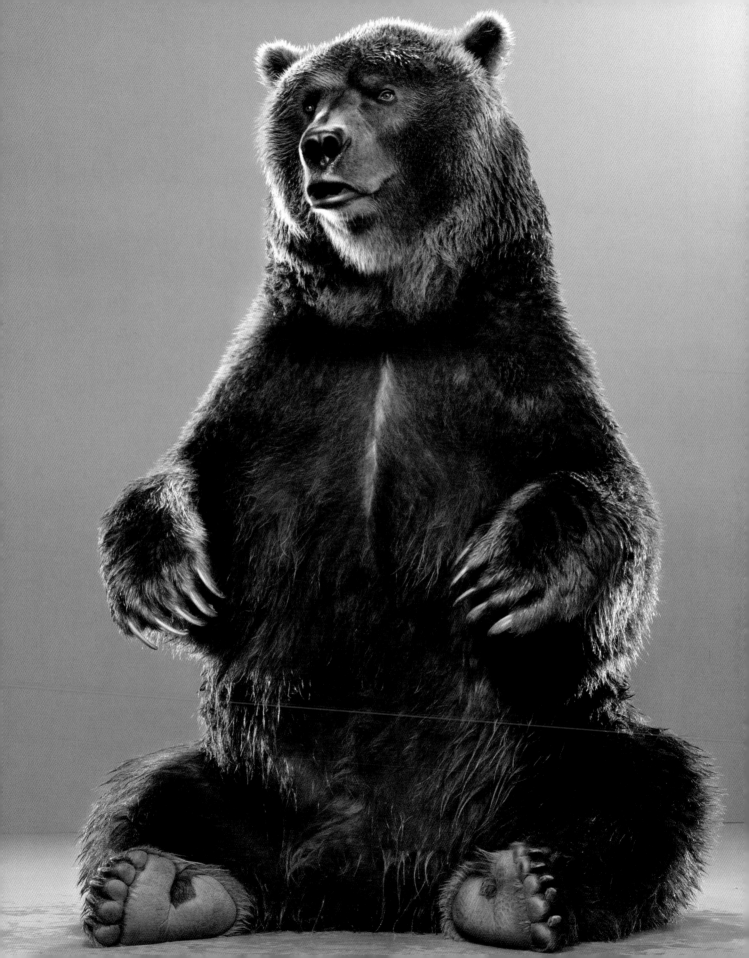

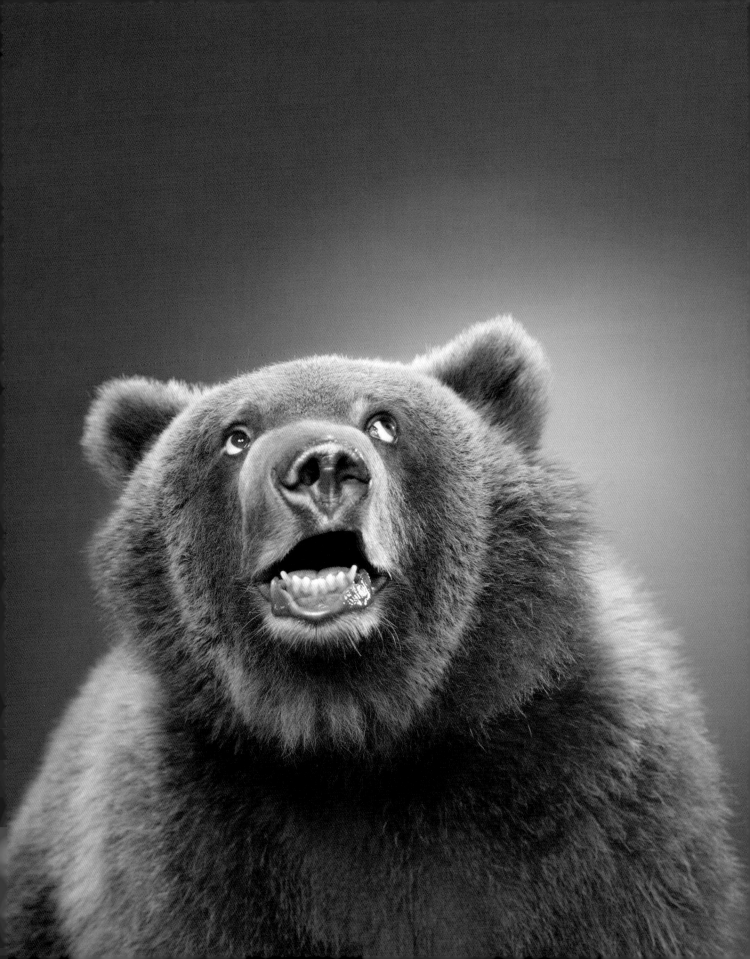

Let the bears pay the bear tax. I pay the Homer tax.
HOMER SIMPSON

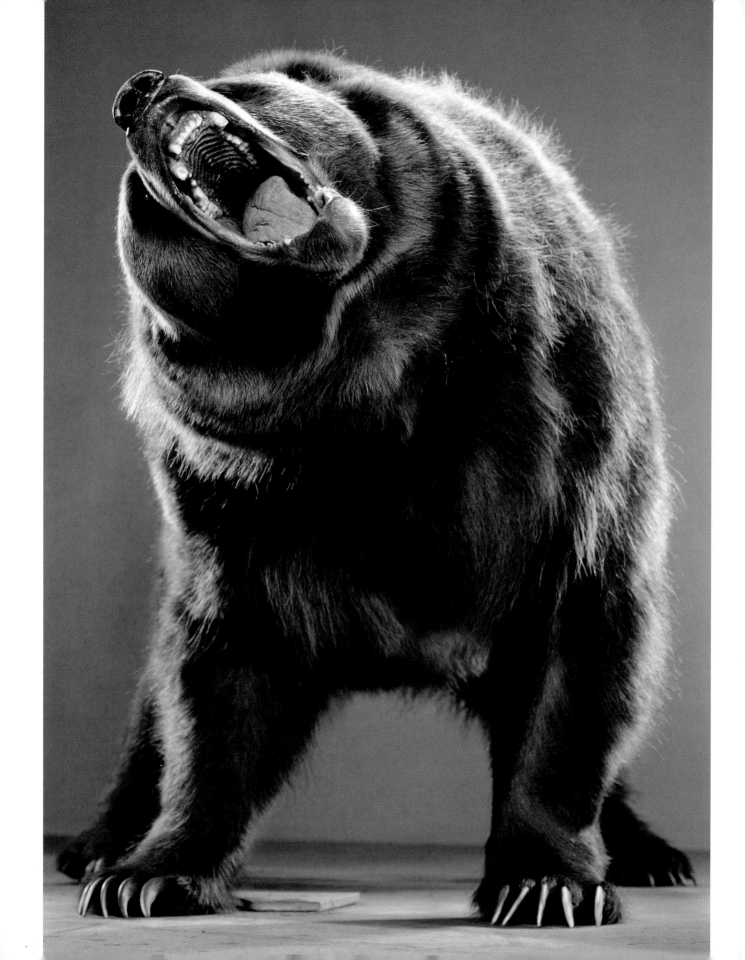

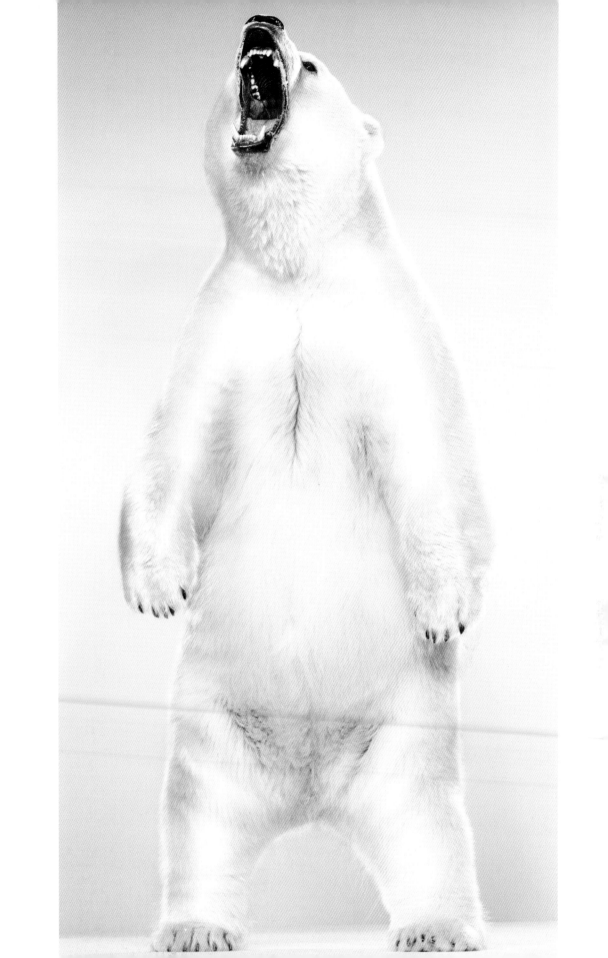

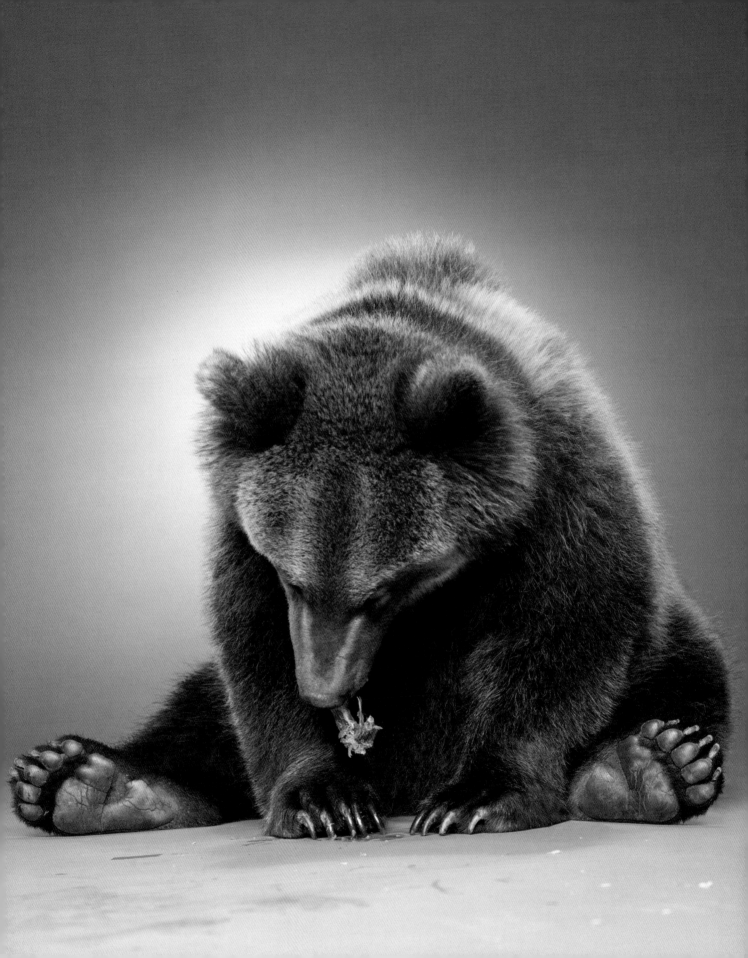

Hunger is insolent, and will be fed.
HOMER

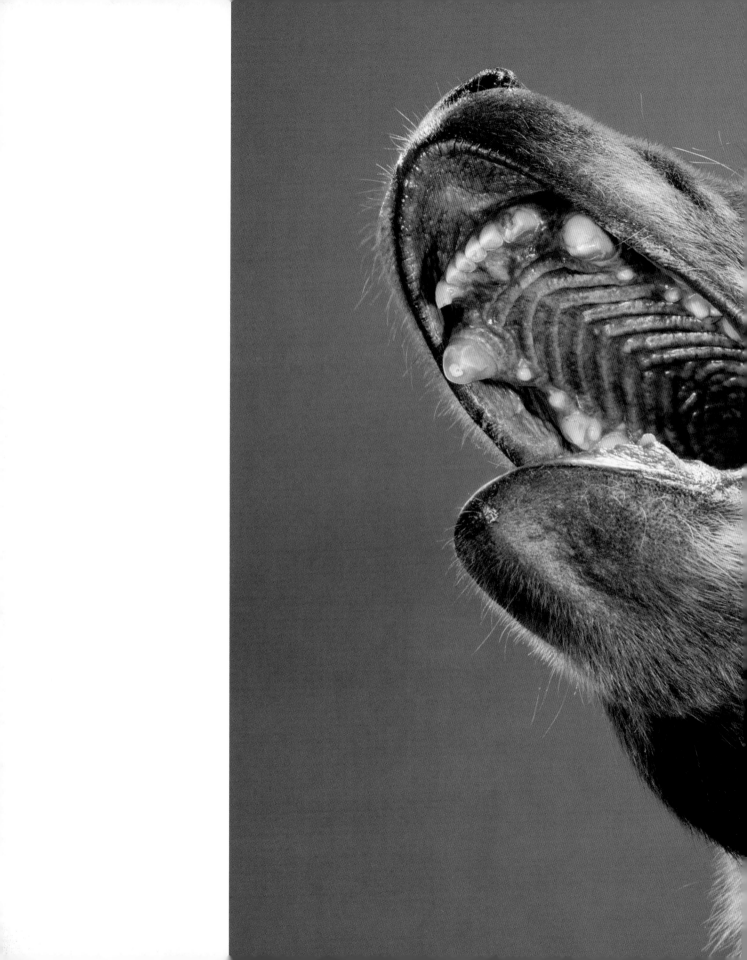

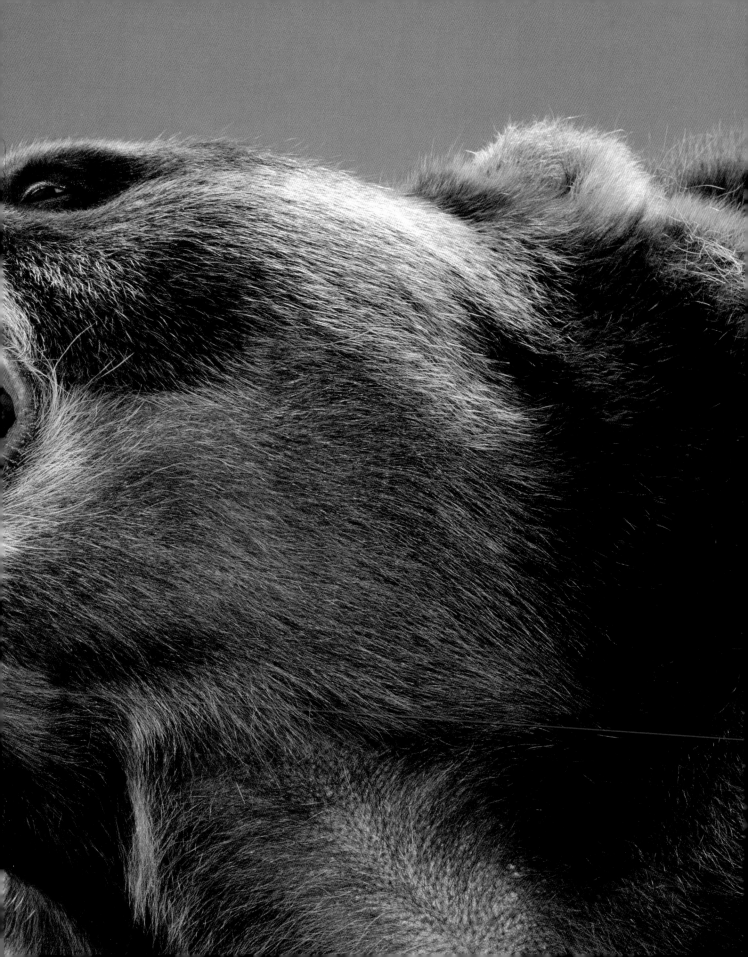

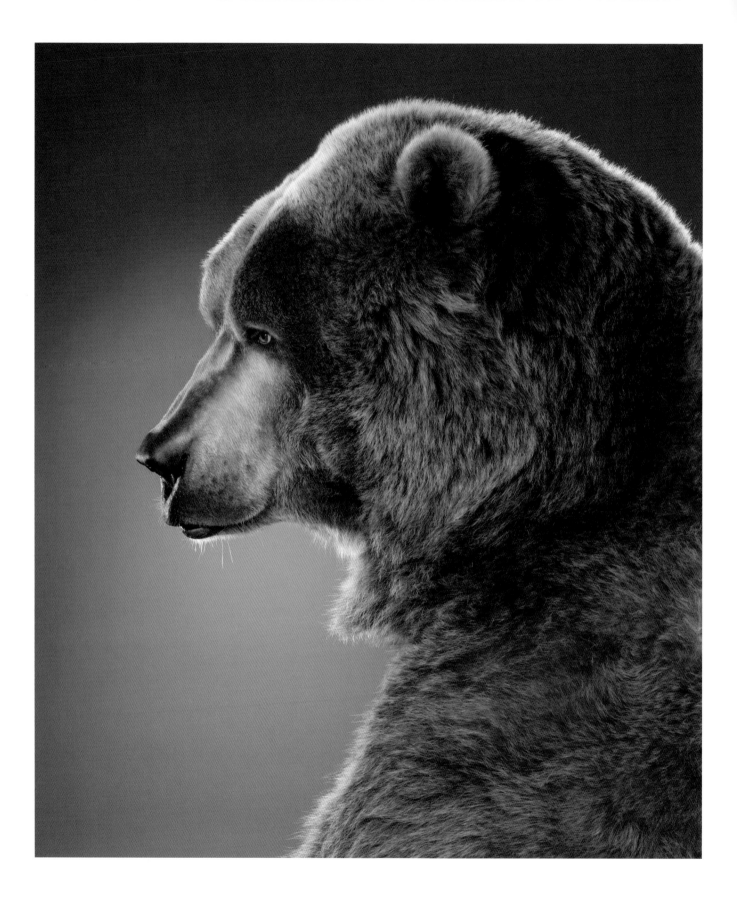

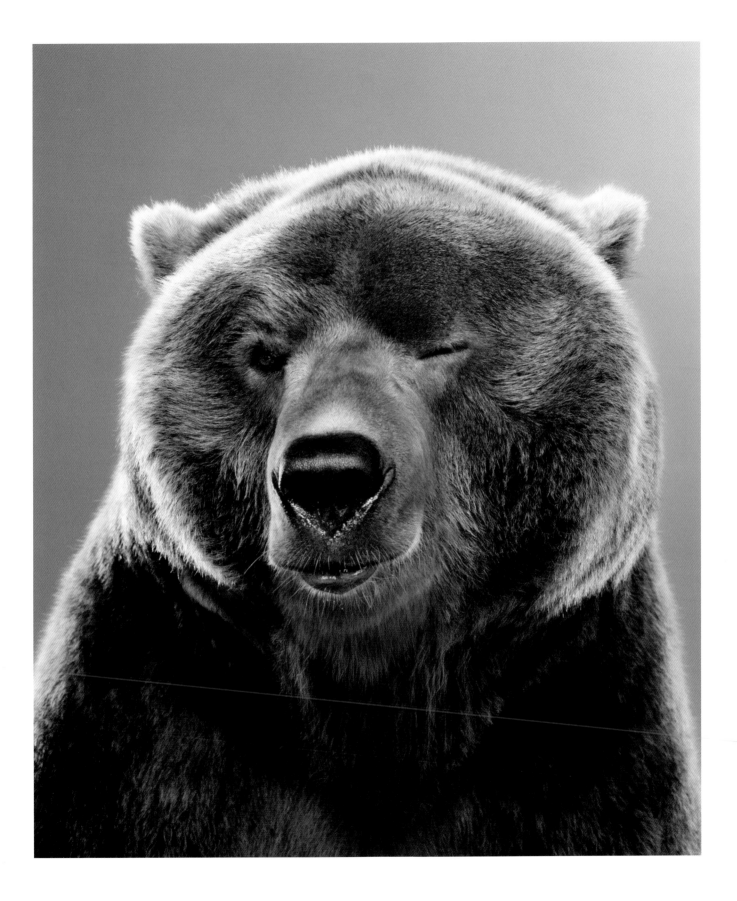

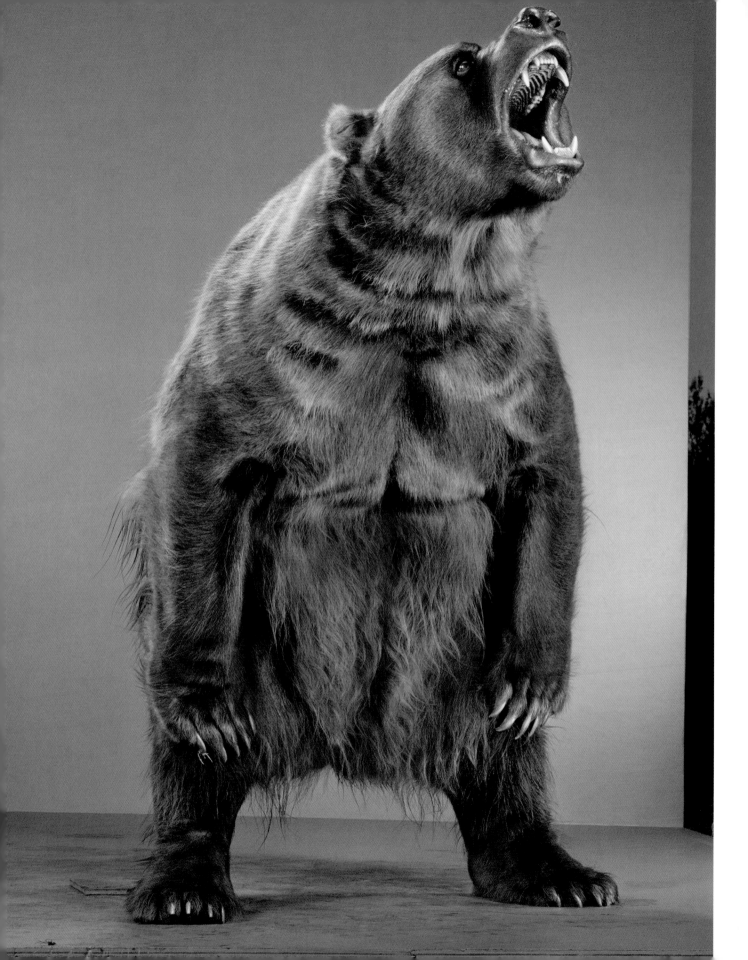

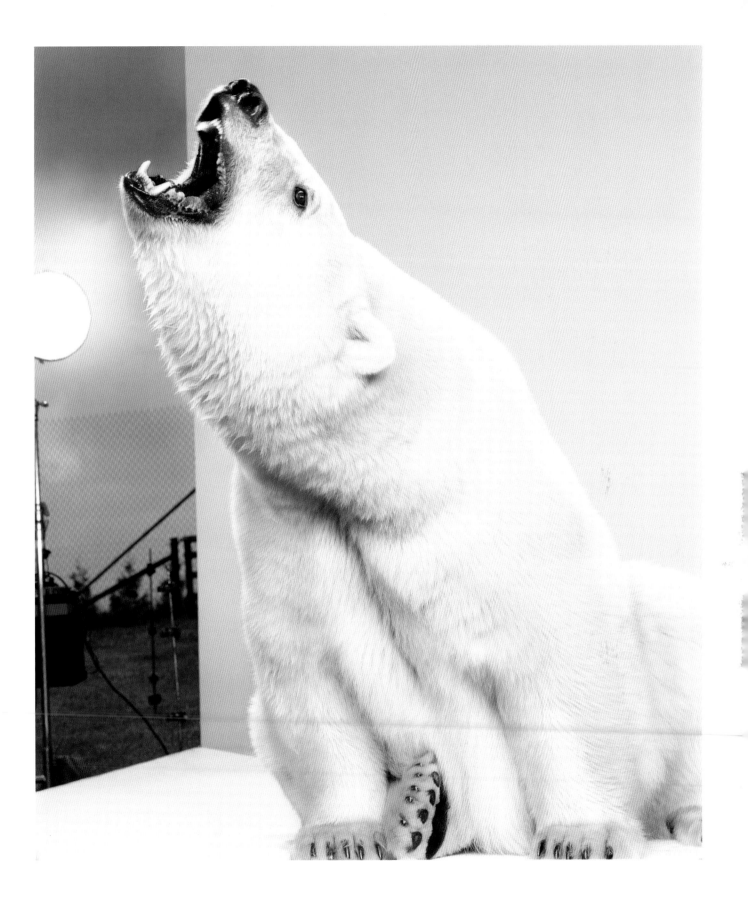

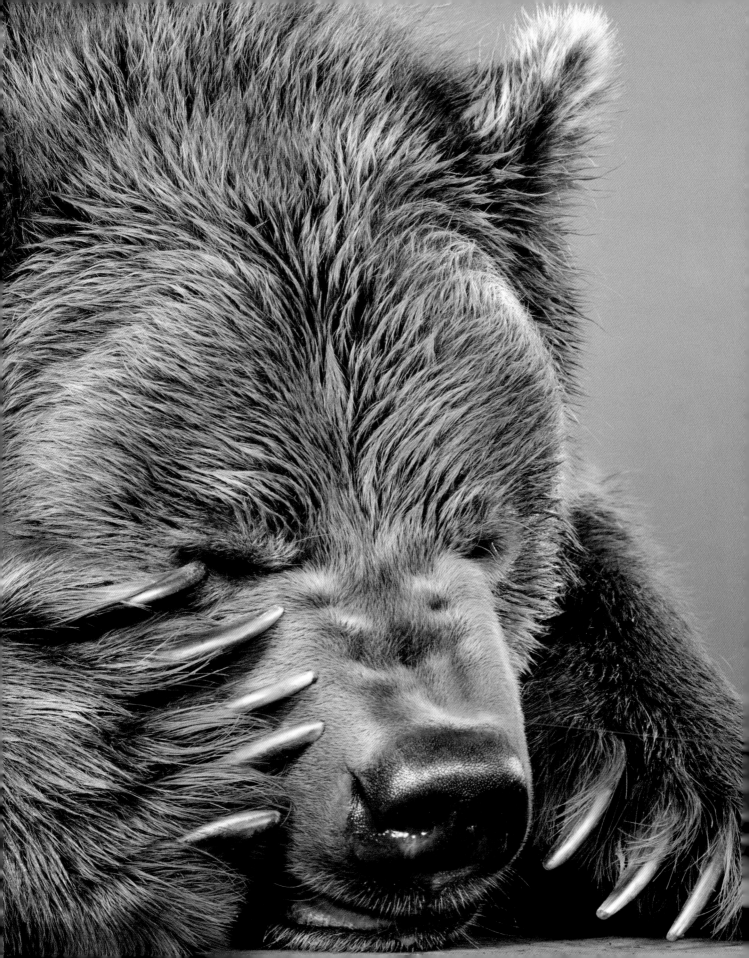

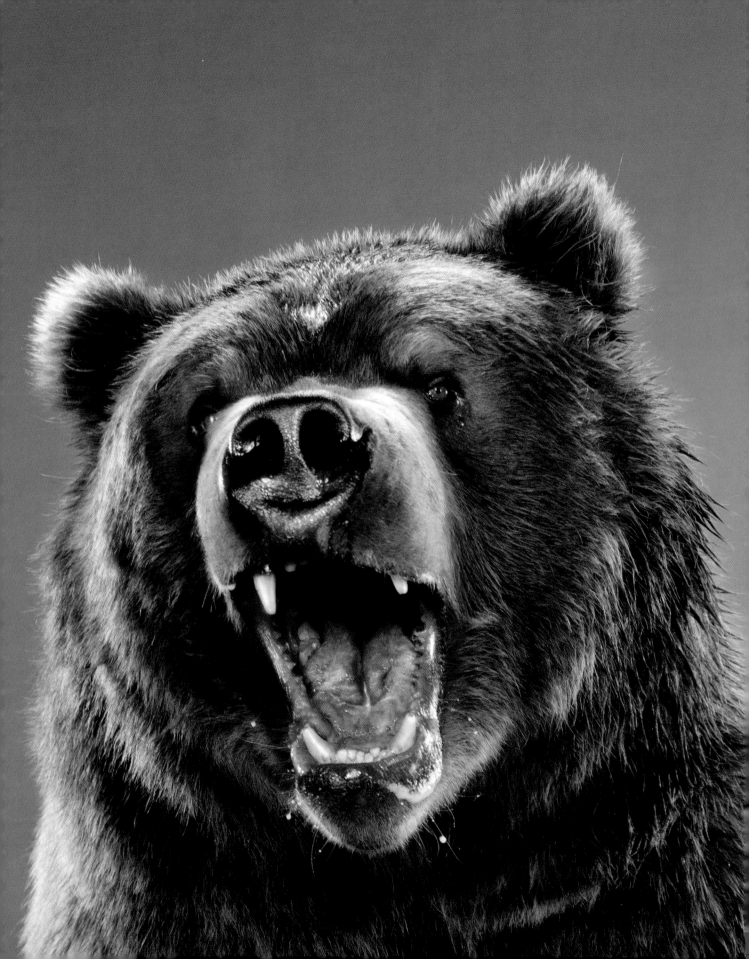

The alleged power to charm down insanity,
or ferocity in beasts, is a power behind the eye.
RALPH WALDO EMERSON

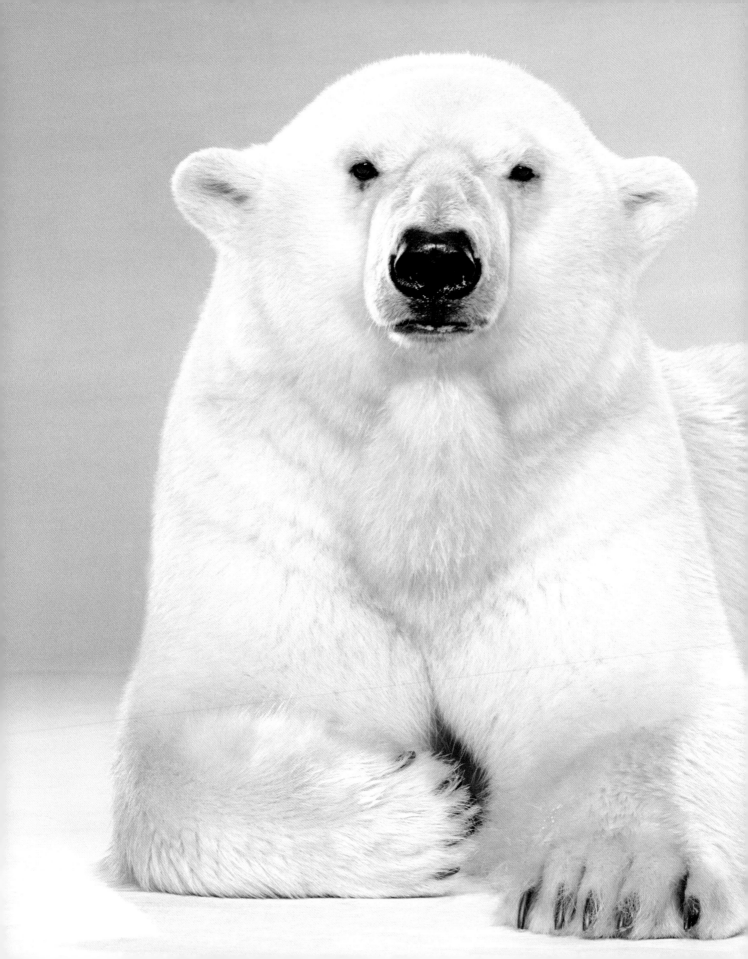

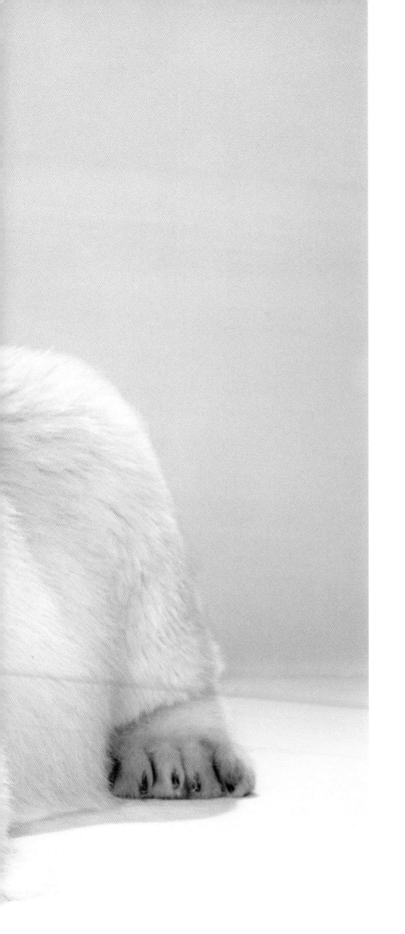

Never do anything standing that you can do sitting,
or anything sitting that you can do lying down.
CHINESE PROVERB

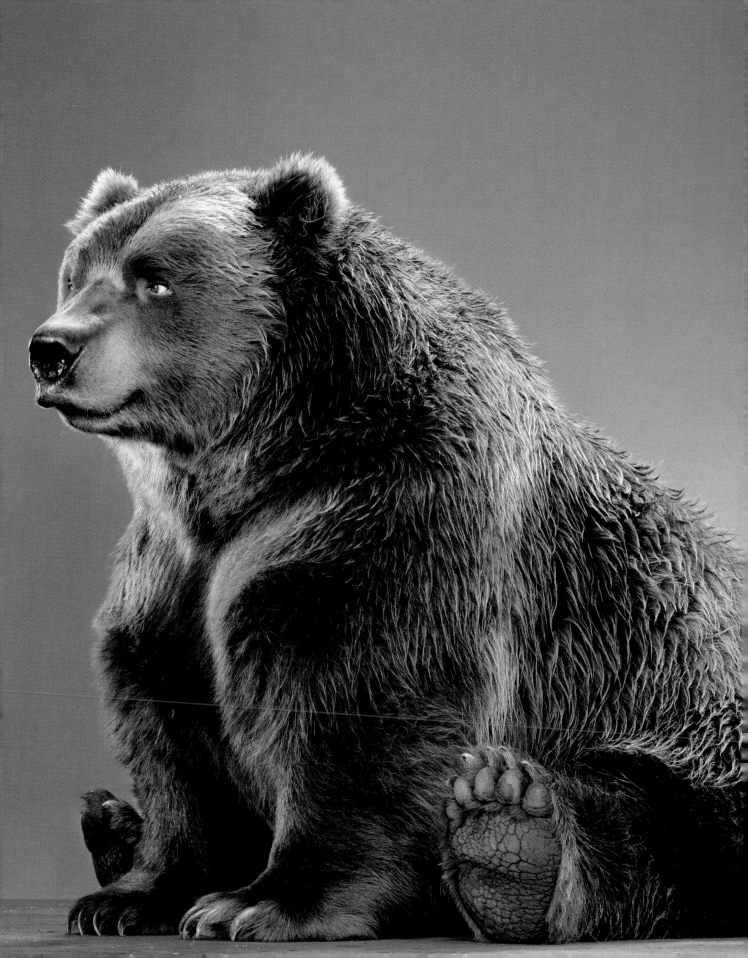

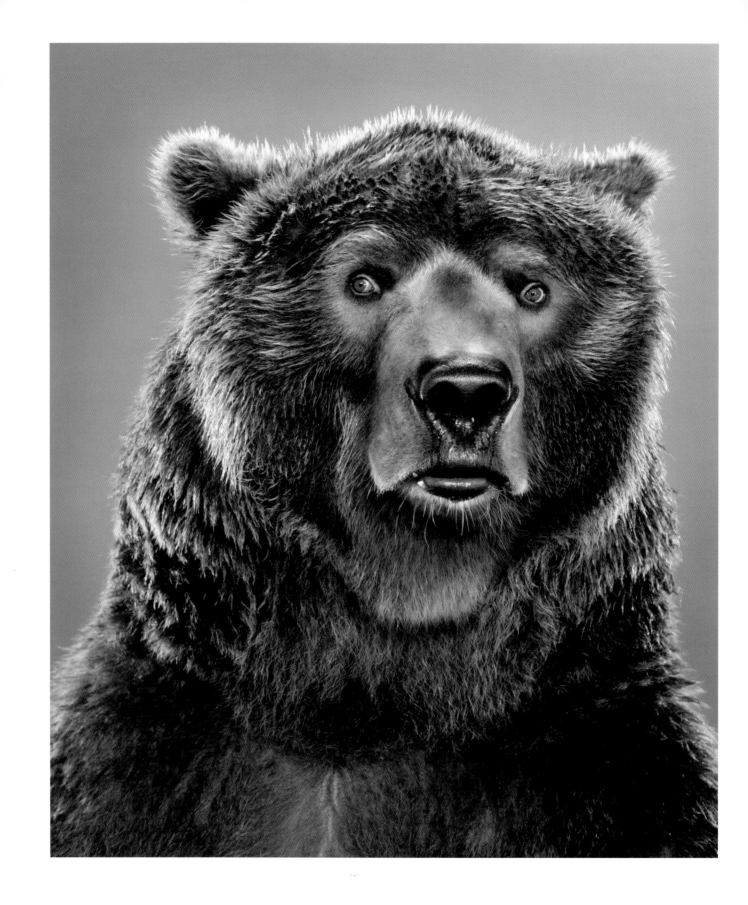

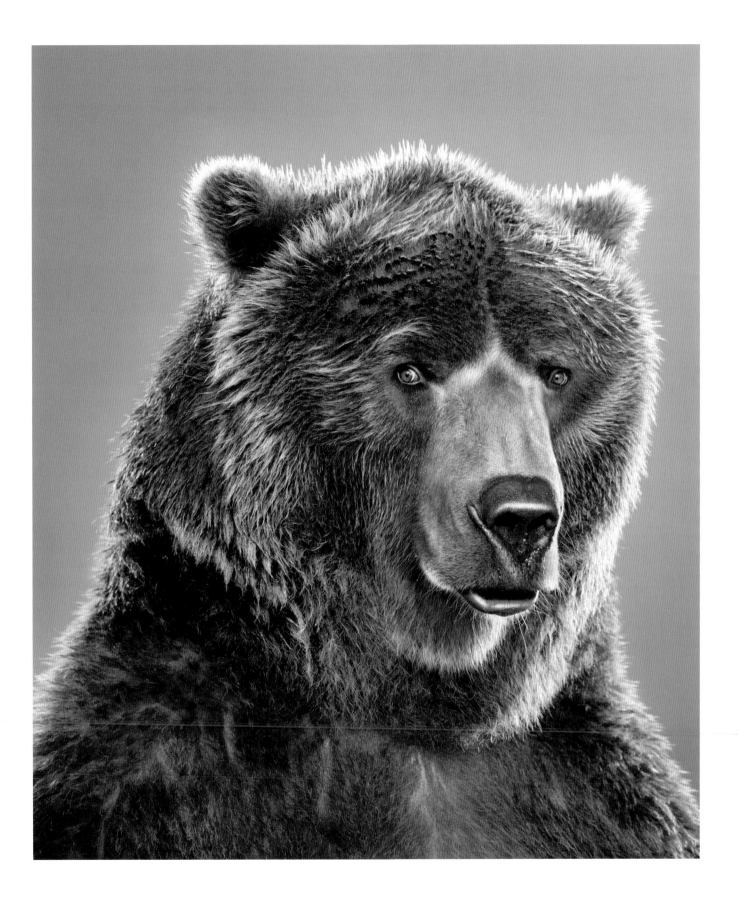

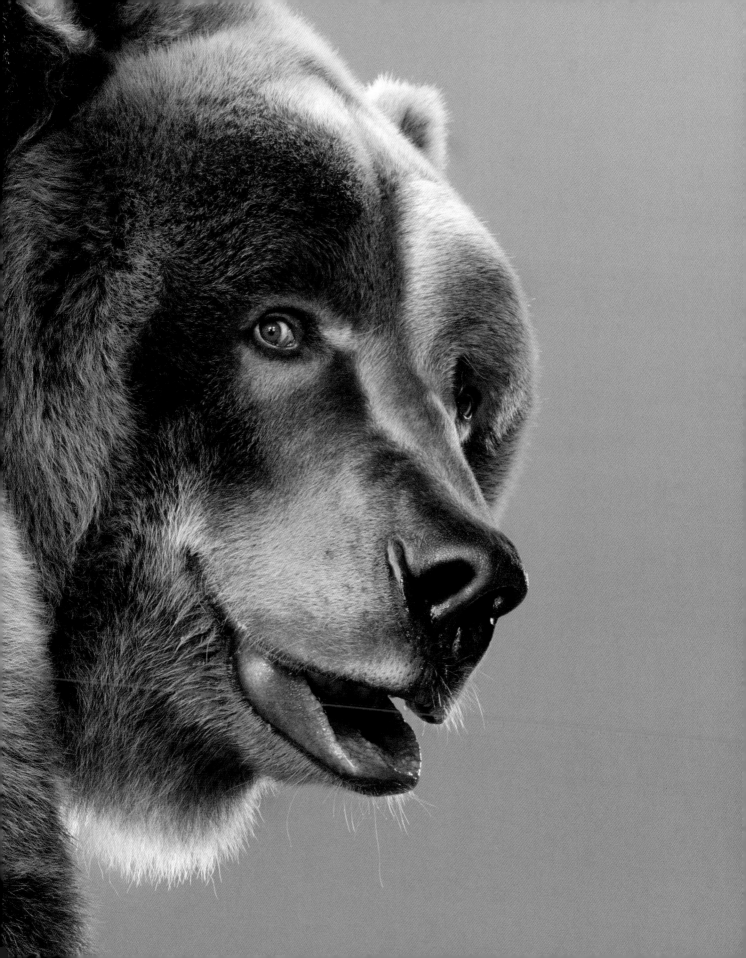

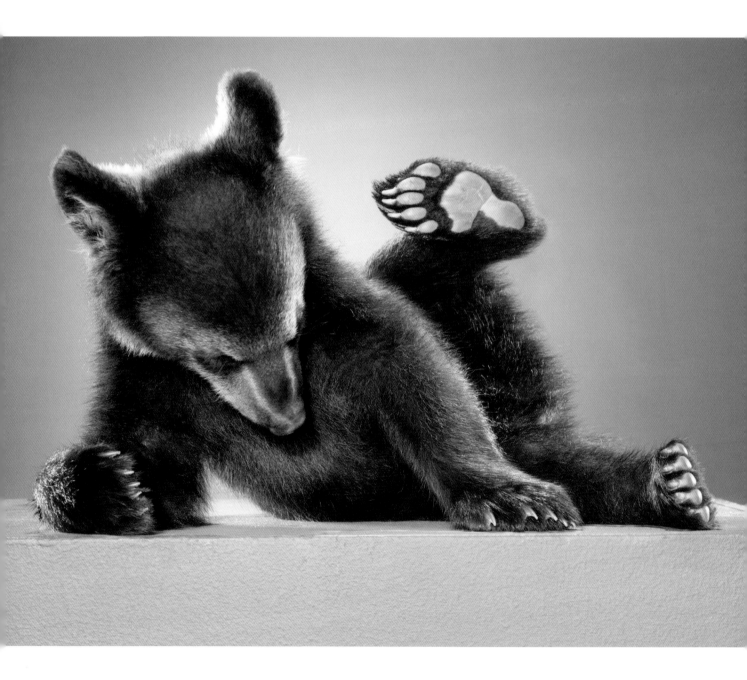

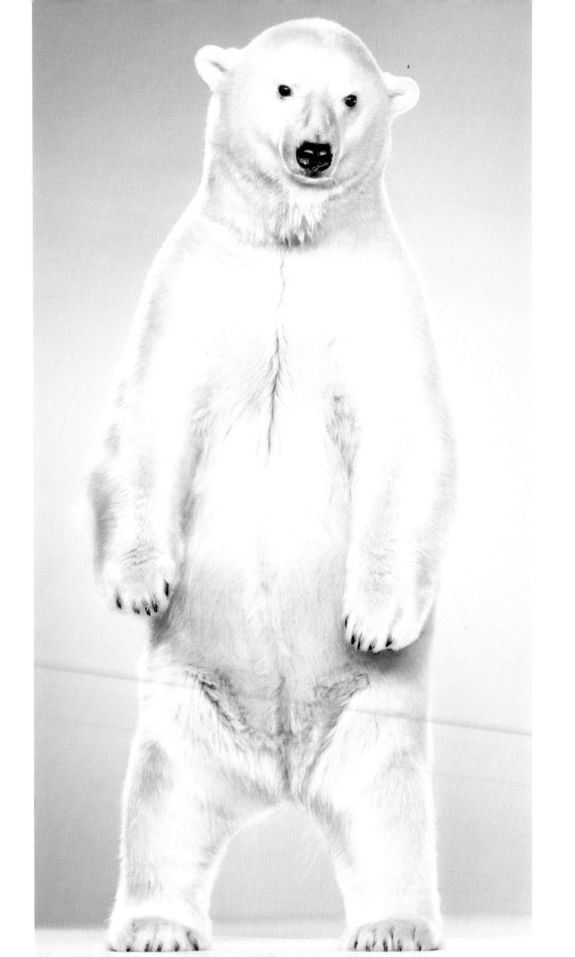

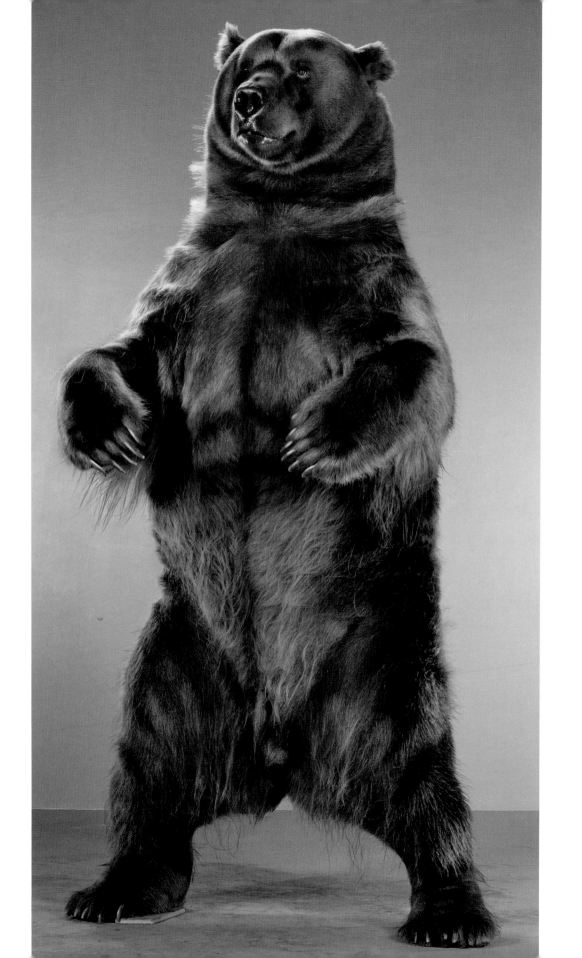

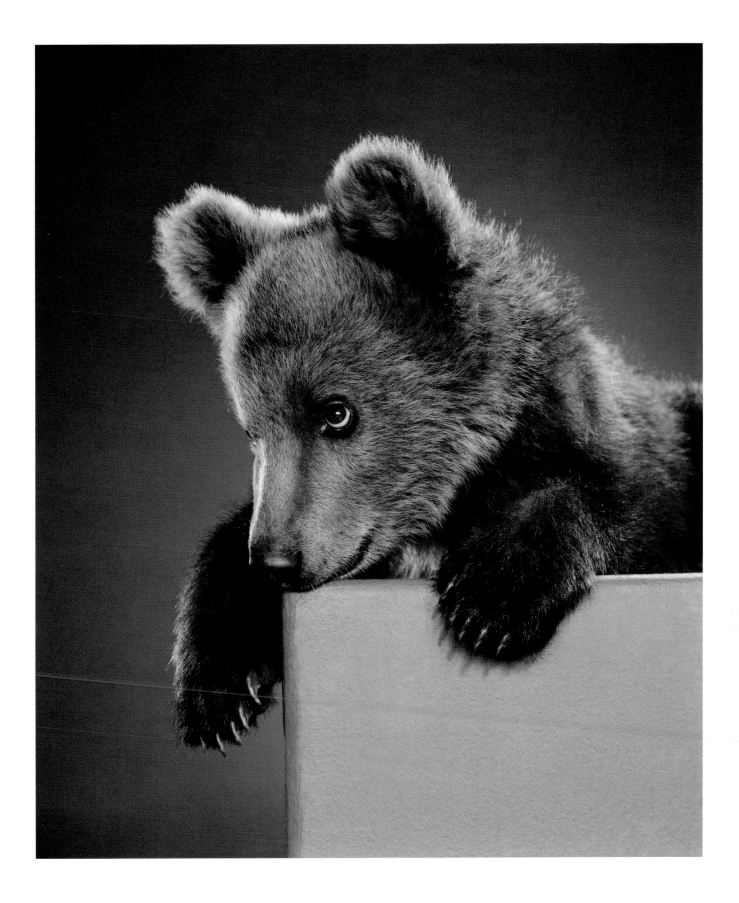

I have seen many a bear led by a man:
but I never before saw a man led by a bear.
JAMES BOSWELL

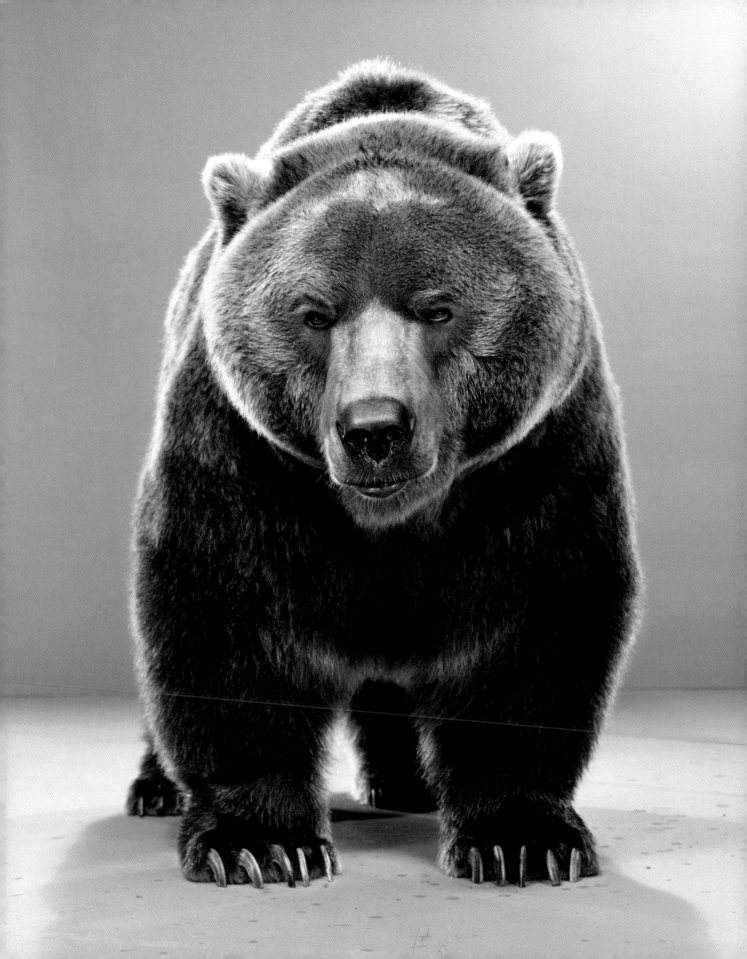

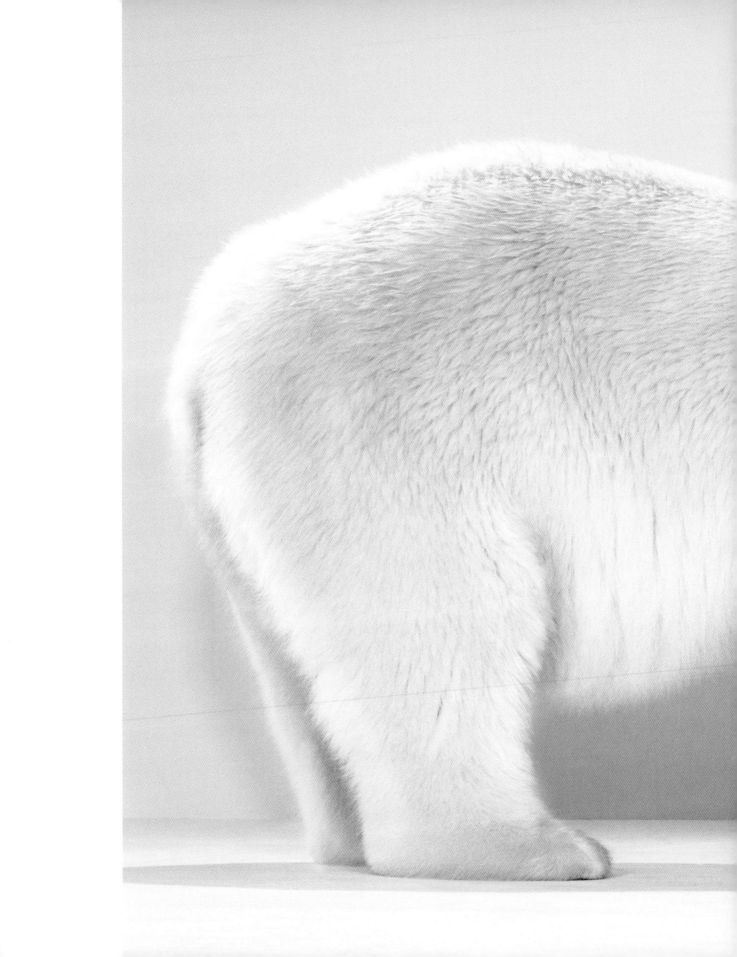

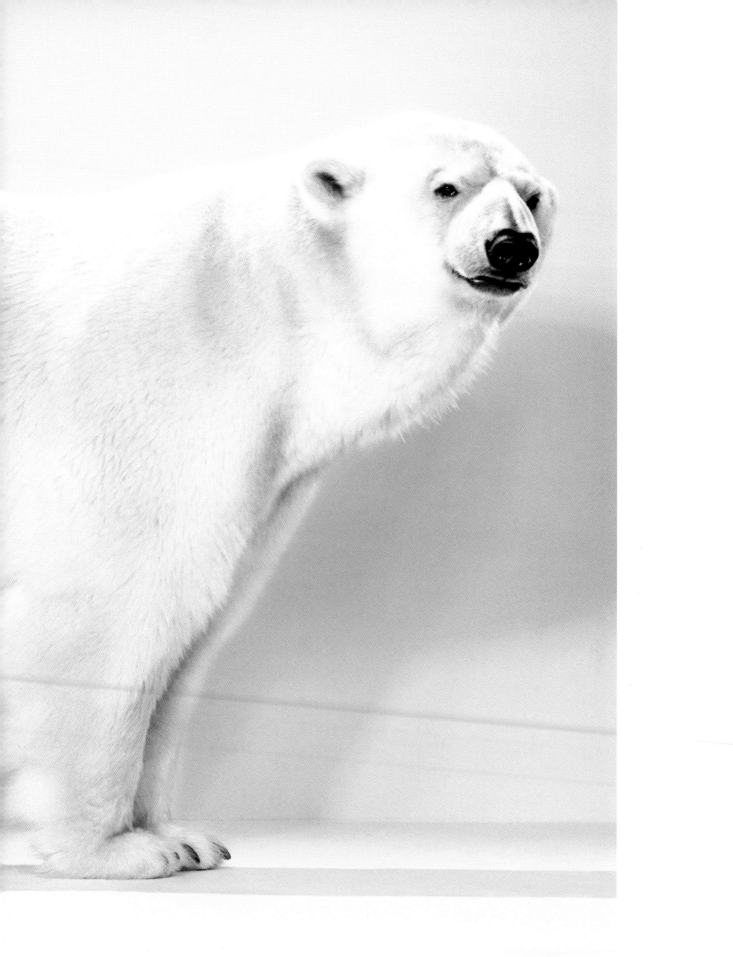

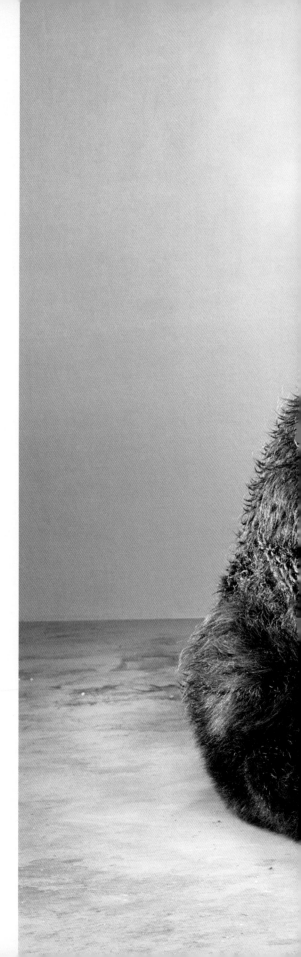

Worry gives a small thing a big shadow.
SWEDISH PROVERB

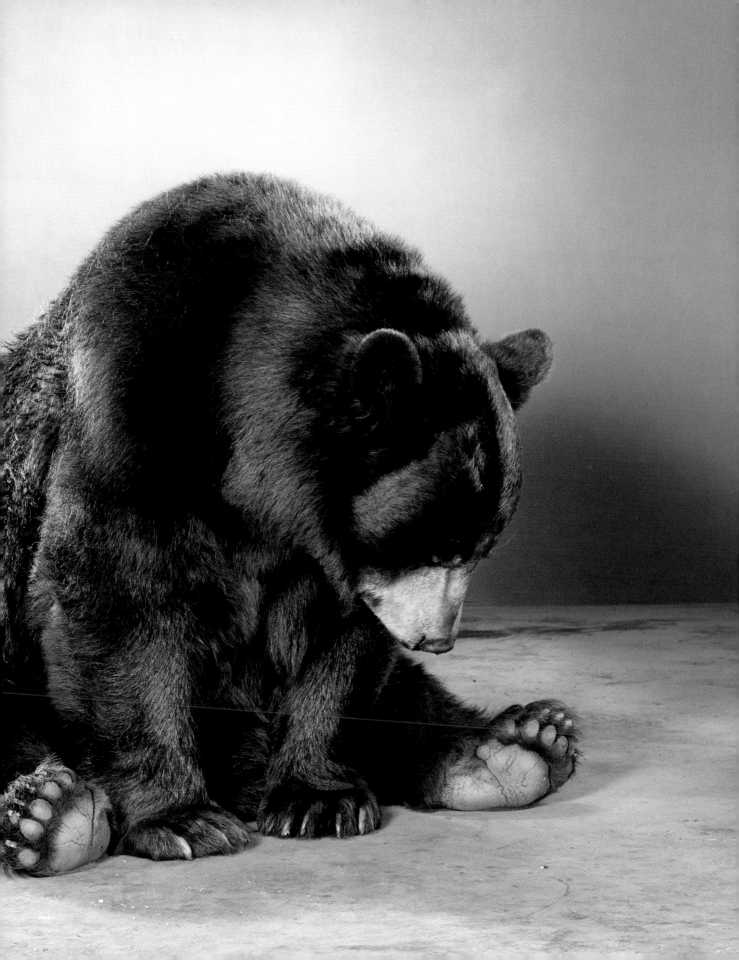

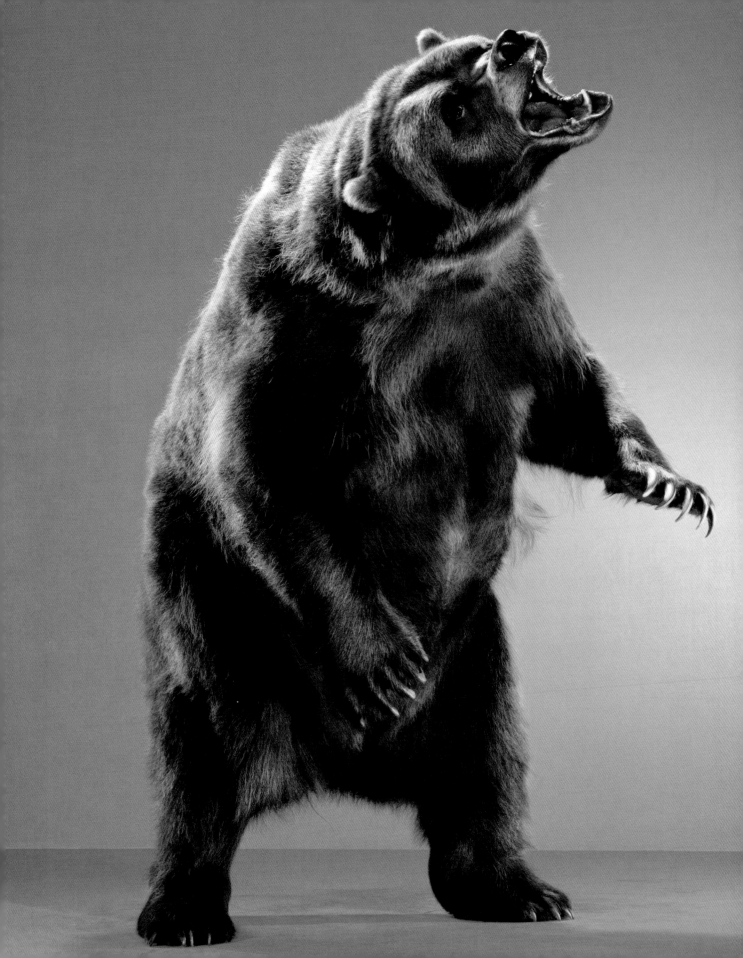

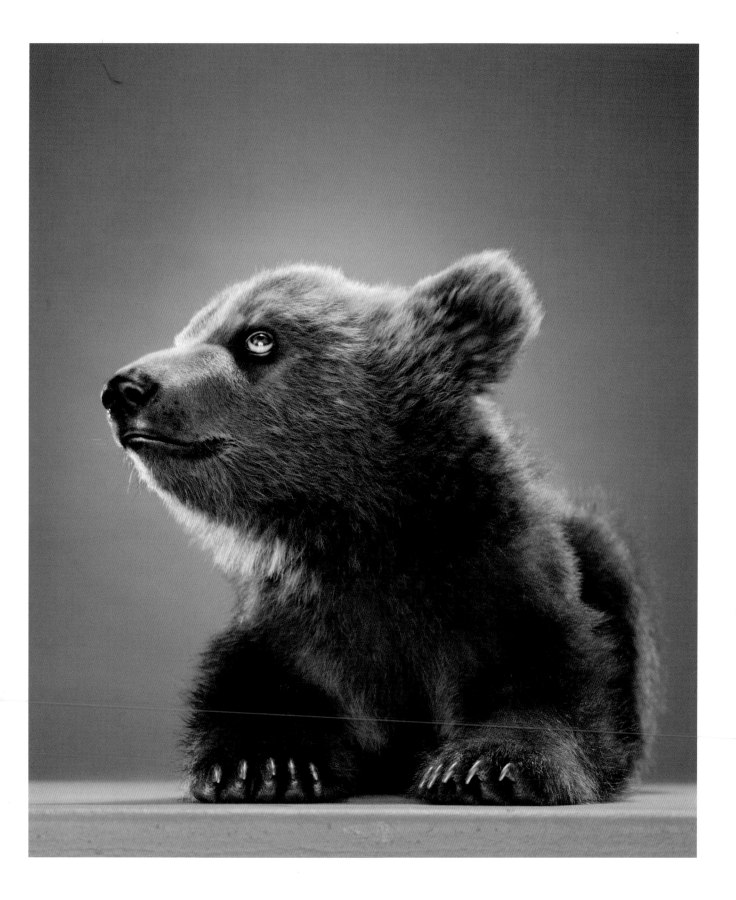

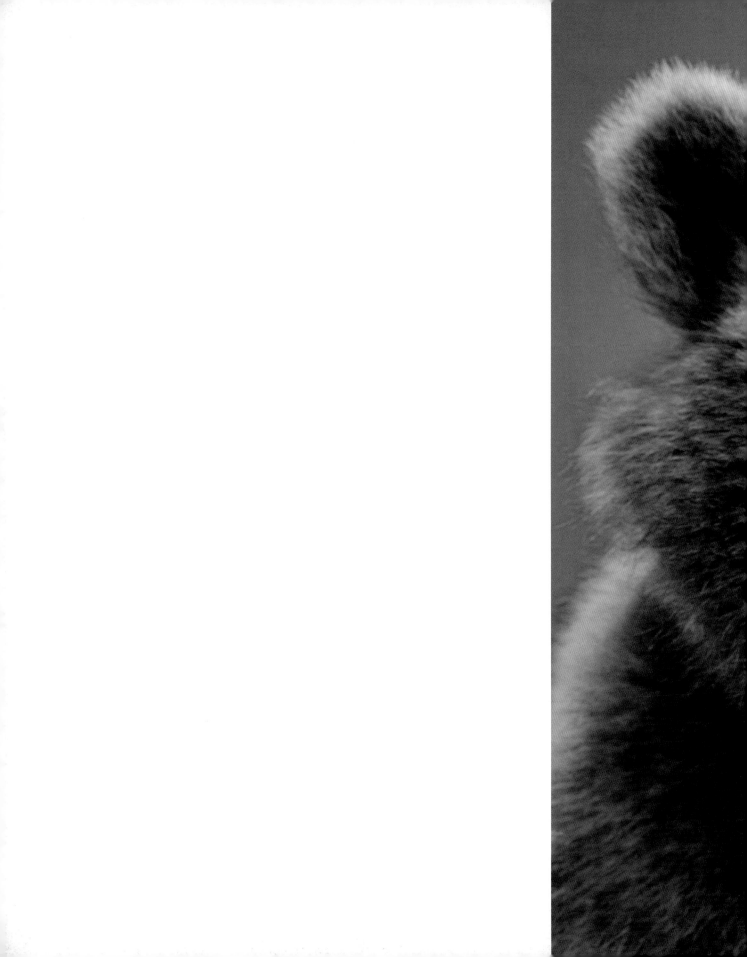

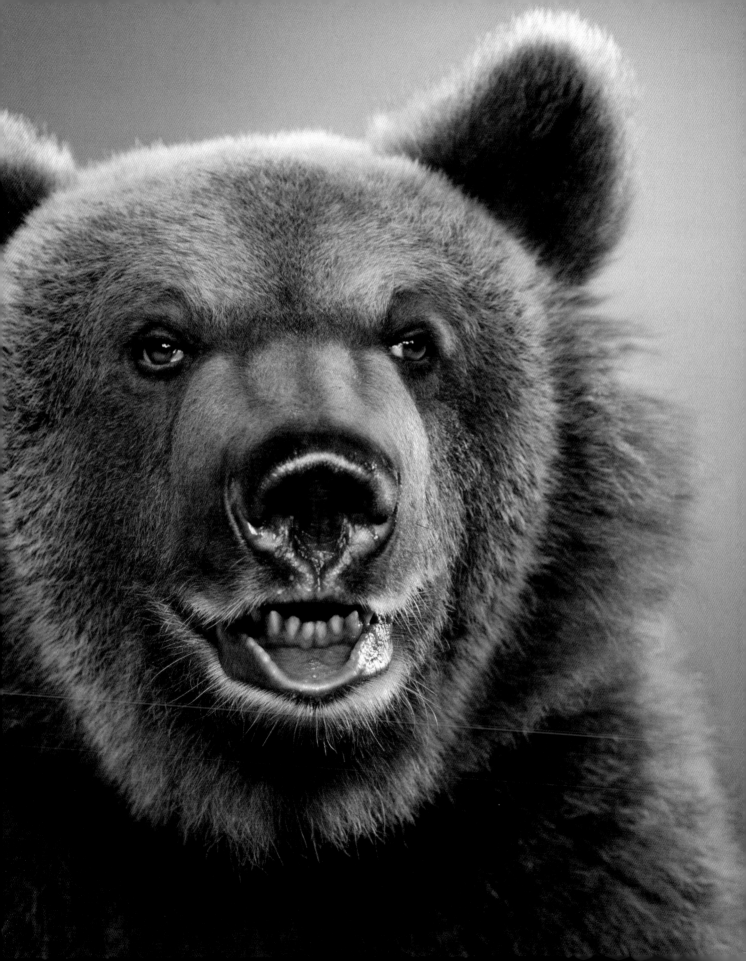

Silly old bear.
CHRISTOPHER ROBIN

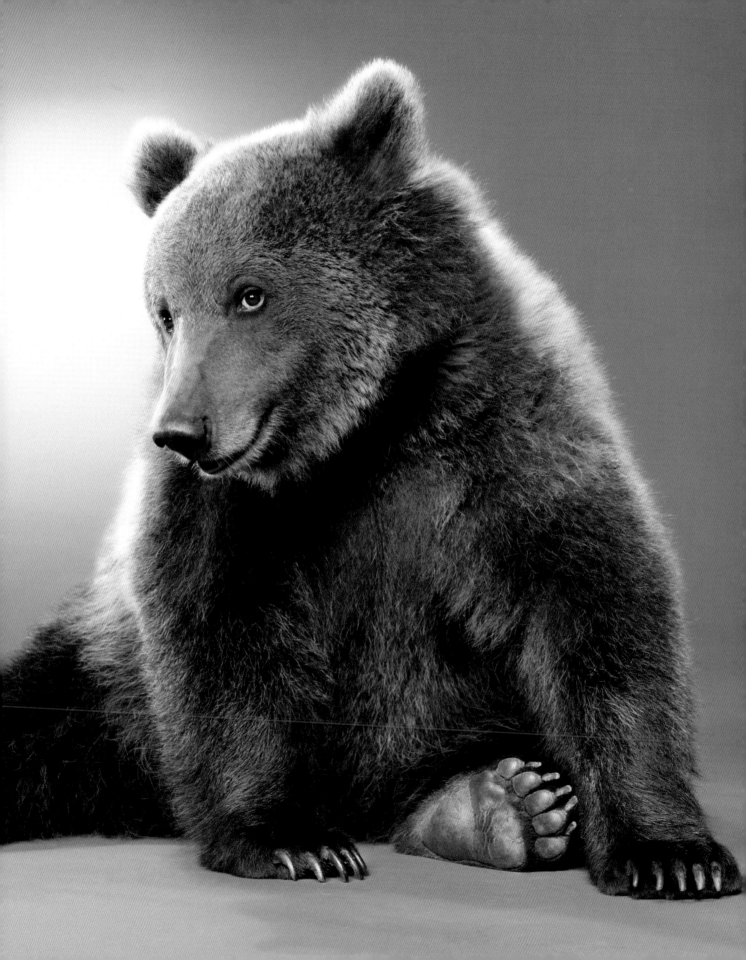

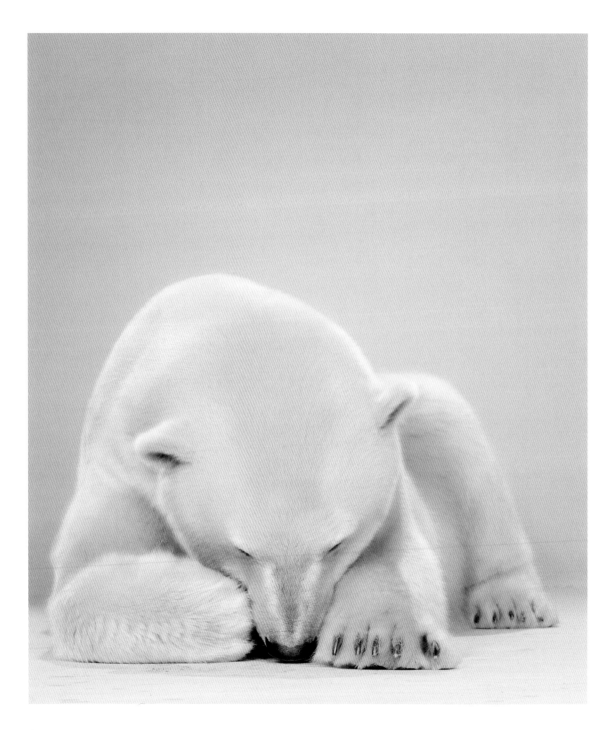

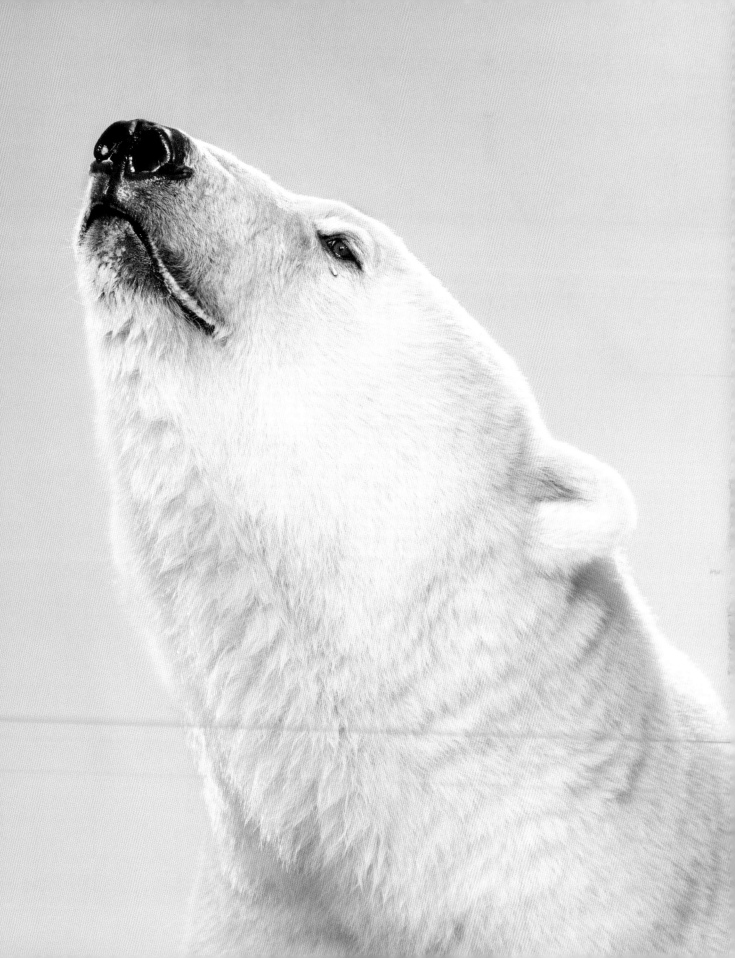

If one is not to get into a rage sometimes,
what is the good of being friends?
GEORGE ELIOT

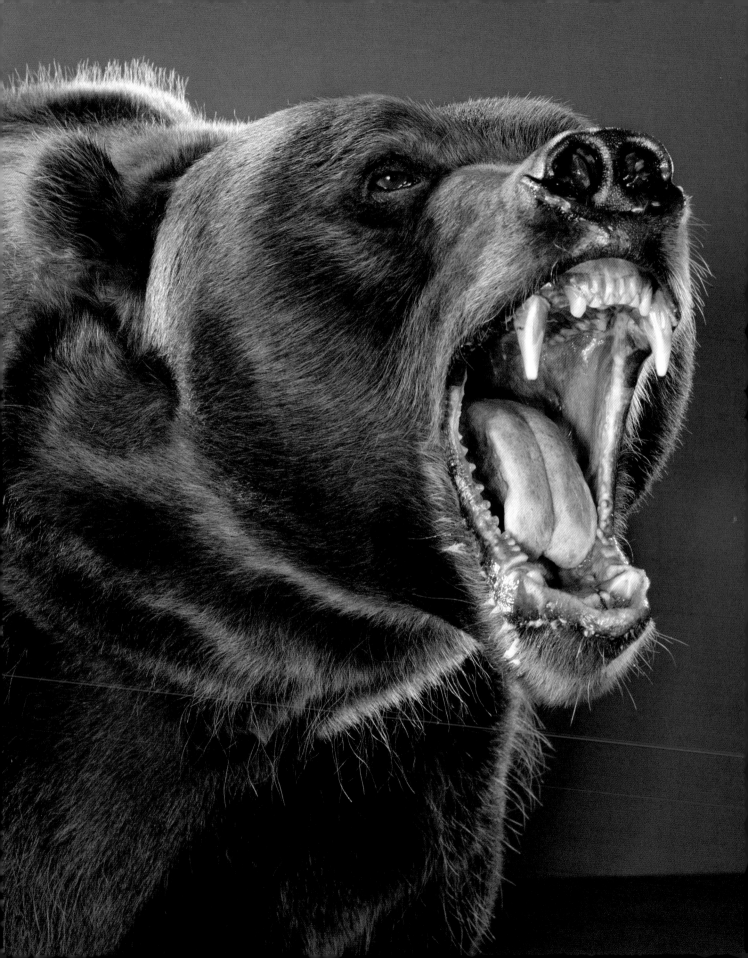

Now this is not the end. It is not even the beginning of the end.
But it is, perhaps, the end of the beginning.
WINSTON CHURCHILL

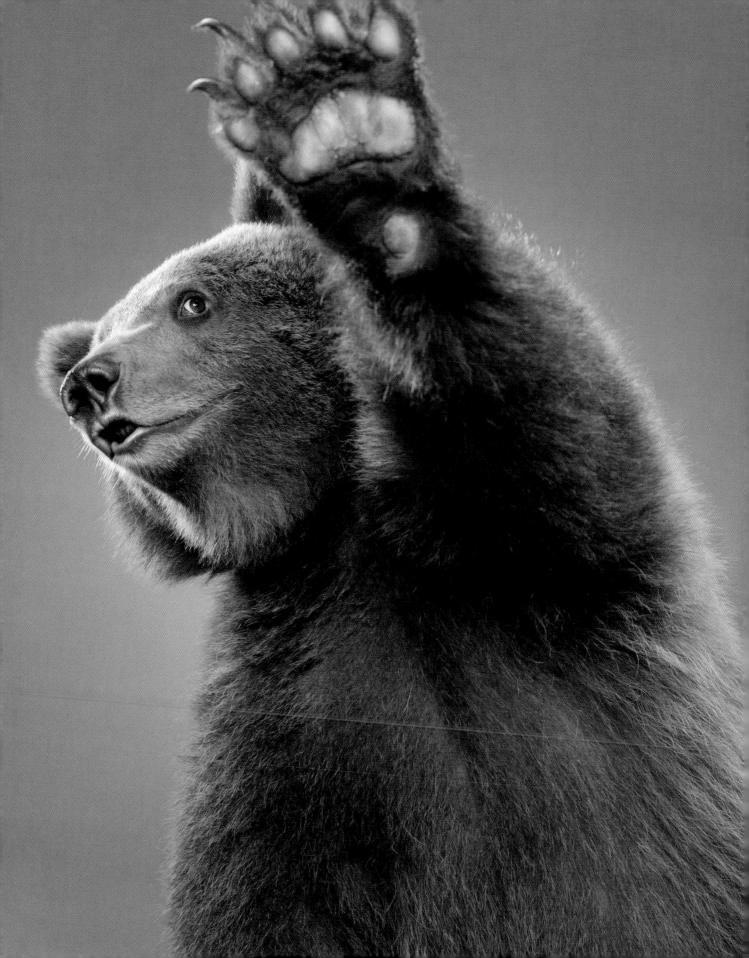

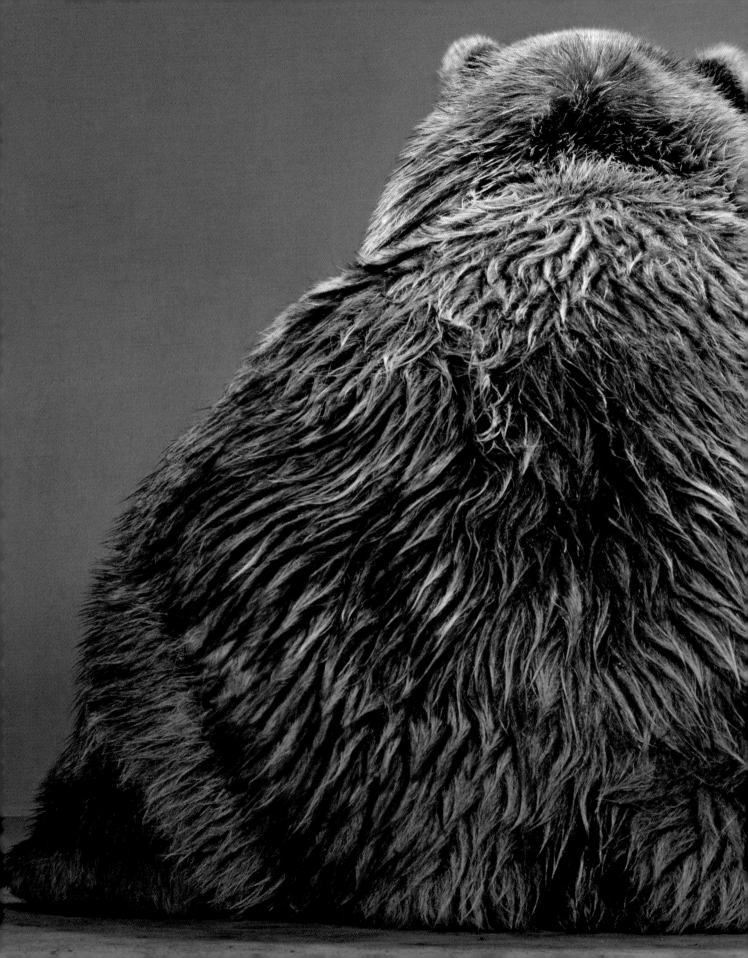

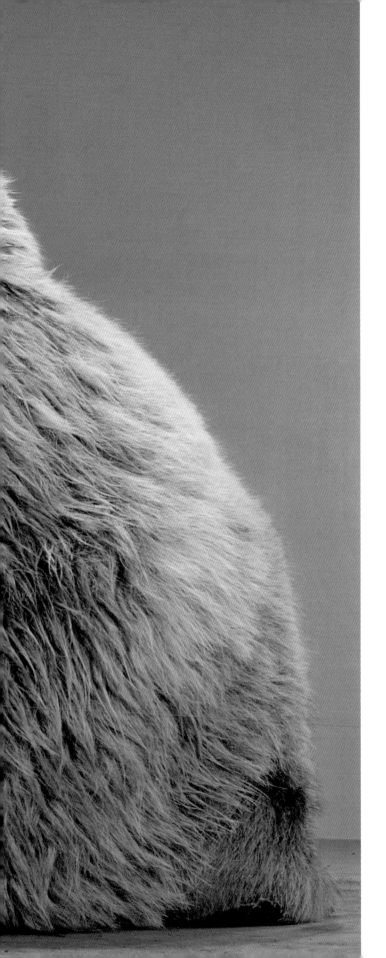

Exit, pursued by a bear.

WILLIAM SHAKESPEARE, *The Winter's Tale*

 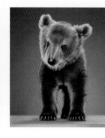 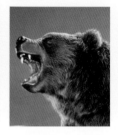 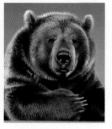 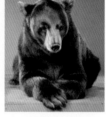

Agee

Polar Bear

Height: 7 feet

Weight: 800 pounds

Residence:
Abbotsford, BC,
Canada

Credits:

Climate Change

Tragically Hip music
video

Out Cold

"Amazing Animal Tales"
ABC special

"Wranglers" BBC
special

Mystery, Alaska

Alaska

Ali Oop

Kodiak

Height: 8 feet+

Weight: 1,400 pounds

Residence:
Innisfail, Alberta,
Canada

Credits:

Grizzly Falls

True Heart

Wild America

*Grizzly Adams: The
Treasure of the Bear*

Dr. Dolittle 2

The Last Trapper

Amos

European Brown Bear
(4 months at the time
photographs were
made)

Weight: 40 pounds

Residence:
Frazier Park, CA

Credits:

*The Tonight Show
with Jay Leno*

Barney

Kodiak

Height: 7.5 feet

Weight: 1,000 pounds

Residence:
Innisfail, Alberta,
Canada

Credits:

Grizzly Falls

Anchorman

Shoebox Zoo

Betty

Kodiak

Height: 7 feet

Weight: 1,000 pounds

Residence:
Innisfail, Alberta,
Canada

Credits:

Dr. Dolittle 2

Anchorman

Bonkers

Black Bear

Height: 6 feet+

Weight: 600 pounds

Residence:
Innisfail, Alberta,
Canada

Credits:

*The Jungle Book:
Mowgli's Story*

Gentle Ben 1 & 2

Brokeback Mountain

The Sopranos

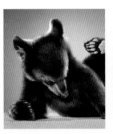

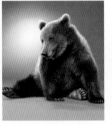

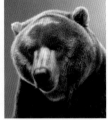

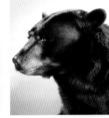

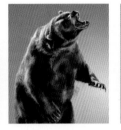

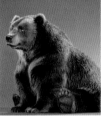

Brett

Black Bear

Height: 1 foot to top of head when on all fours; 30 inches on hind legs

Weight: 12 pounds

Residence: Frazier Park, CA

Credits: *Entertainment Tonight*

Cheyenne

Russian Brown Bear

Height: 5 feet

Weight: 180 pounds

Residence: San Bernardino Ranch, CA

Credits:
The Tonight Show with Jay Leno

The Ellen DeGeneres Show

The Morning Show with Mike and Juliet

Fired Up

Koda

Grizzly

Height: 9 feet

Weight: 1,600 pounds

Residence: Frazier Park, CA

Credits:
Kevin of the North

Gold Diggers

Snow Dogs

Tribe of Joseph

The Wild Guys

Grizzly Rage

Fantastic Four: Rise of the Silver Surfer

Max

Black Bear

Height: 6 feet

Weight: 400 pounds +

Residence: Vancouver, Canada

Credits:
Spirit Bear: The Simon Jackson Story

Dreamcatcher

Tin Man

Dead Like Me

Animal Miracles

Get Bear Smart PSA

Ursula

Kodiak

Height: 7 feet

Weight: 850 pounds

Residence: Innisfail, Alberta, Canada

Credits:
Grizzly Falls

Anchorman

True Heart

Wild America

Whopper

Kodiak

Height: 7 feet

Weight: 1,000 pounds

Residence: Innisfail, Alberta, Canada

Credits:
Grizzly Falls

Anchorman

Air Bud 2

Return to Grizzly Mountain

The Last Trapper

For Violet and Zeddy and Rob, my teddy bear

Acknowledgments

Sincere thanks to all of the fearless animal trainers who assisted me in "getting the shot": Ruth LaBarge at Bear with Me, Mark Dumas at Beyond Bears, and Benay's agency in Los Angeles. Thanks to Brian Paul Clamp at Clamp Art Gallery in New York City, David Fahey and Giselle Schmidt at Fahey/Klein Gallery, Los Angeles; Simon Green, my tenacious book agent; and Michael Sand, my patient editor at Little, Brown. And most of all, thanks to my husband, Robert Green, for having faith that I would come home in one piece.

Little, Brown and Company
Hachette Book Group
237 Park Avenue, New York, NY 10017
Visit our Web site at www.HachetteBookGroup.com

First Edition: November 2009

Little, Brown and Company is a division of Hachette Book Group, Inc. The Little, Brown name and logo are trademarks of Hachette Book Group, Inc.

ISBN 978-0-316-03188-2
LCCN 2009922822

10 9 8 7 6 5 4 3 2 1

Design by Empire Design Studio
Printed in China